Magic Lantern Guides®

Canon

EOS *REBEL XSi*

EOS 450D

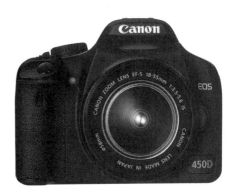

Michael Guncheon

LARK BOOKS
A Division of Sterling Publishing Co., Inc.
New York / London

Book Design and Layout: Michael Robertson
Cover Design: Thom Gaines – Electron Graphics

Library of Congress Cataloging-in-Publication Data

Guncheon, Michael A., 1959-
 Magic lantern guides : Canon EOS Rebel XSi/EOS 450D / Michael A.
Guncheon. -- 1st ed.
 p. cm.
 Includes index.
 ISBN 978-1-60059-416-8 (PB-trade pbk. : alk. paper)
 1. Canon digital cameras--Handbooks, manuals, etc. 2. Digital
cameras--Handbooks, manuals, etc. I. Title.
 TR263.C3G975 2008
 771.3'3--dc22
 2008021810

10 9 8 7 6 5 4 3 2 1
First Edition

Published by Lark Books, A Division of
Sterling Publishing Co., Inc.
387 Park Avenue South, New York, N.Y. 10016

Text © 2008, Michael Guncheon
Photography © 2008, Michael Guncheon unless otherwise specified

Magic Lantern Guides® is a registered trademark of Sterling Publishing Co., Inc.

Distributed in Canada by Sterling Publishing,
c/o Canadian Manda Group, 165 Dufferin Street
Toronto, Ontario, Canada M6K 3H6

Distributed in the United Kingdom by GMC Distribution Services,
Castle Place, 166 High Street, Lewes, East Sussex, England BN7 1XU

Distributed in Australia by Capricorn Link (Australia) Pty Ltd.,
P.O. Box 704, Windsor, NSW 2756 Australia

If you have questions or comments about this book, please contact:
Lark Books
67 Broadway
Asheville, NC 28801
(828) 253-0467

Manufactured in USA

ISBN 13: 978-1-60059-416-8

For information about custom editions, special sales, premium and corporate purchases, please con-
tact Sterling Special Sales Department at 800-805-5489 or specialsales@sterlingpub.com.

Contents

Digital Photography: The Revolution Continues 13
Differences between Digital and Film Photography 15
 Film vs. the Sensor ... 16
 The LCD Monitor ... 16
 The Histogram ... 17
 Film vs. Memory Cards .. 18
 More Photos ... 18
 Reusable .. 19
 Durability ... 19
 No ISO Limitations .. 19
 Small Size .. 19
 Greater Image Permanence .. 19
 ISO ... 19
 Noise and Grain .. 21
 File Formats .. 21
 The Color of Light ... 22
 Digital Resolution ... 23
 Dealing with Resolution ... 23
 Cost of Shooting ... 25

Features and Functions .. 27
Overview of Features ... 28
EOS Rebel XSi – Front View .. 30
EOS Rebel XSi – Back View ... 31
EOS Rebel XSi – Top View .. 32
Camera Controls .. 33
 Mode Dial ... 33
 Main Dial .. 33
 Shutter Button .. 34
 Cross Keys .. 34
Menus Overview .. 35
Camera Activation ... 36
 Power Switch .. 37
 Auto Power Off ... 37

Resetting Controls ... 37
The Viewfinder .. 39
 Viewfinder Adjustment .. 40
The LCD Monitor .. 40
XSi Batteries ... 43
Date/Time .. 45
The Sensor ... 45
Mirror Lockup .. 47
Memory Cards .. 48
Formatting Your Memory Card ... 51
Cleaning the Camera .. 52
 Manually Cleaning the Sensor 55
Getting Started in 10 Basic Steps 56

The Menu System and the LCD Monitor 59
Using the Menus .. 59
 Shooting 1 Menu ... 60
 Shooting 2 Menu ... 61
 Playback Menu .. 61
 Set-up 1 Menu .. 62
 Set-up 2 Menu .. 63
 Set-up 3 Menu .. 64
 My Menu ... 64
 Using My Menu ... 65
Custom Functions .. 67
 C.FN I: Exposure ... 68
 1 Exposure level increments 68
 2 Flash sync speed in Av mode 68
 C.FN II: Image ... 68
 3 Long exposure noise reduction 68
 4 High ISO speed noise reduct'n 69
 5 Highlight tone priority ... 69
 6 Auto Lighting Optimizer 69
 C.FN III: Auto focus/Drive ... 70
 7 AF-assist beam firing ... 70
 8 AF during Live View shooting 70
 9 Mirror lockup .. 70
 C.FN IV: Auto Operation/Others 71
 10 Shutter button/AE lock button 71

11 SET button when shooting .. 71
12 LCD display when power on 72
13 Add original decision data 72
Using the LCD Monitor ... 73
LCD Image Review ... 73
Playback .. 75
Automatic Image Rotation 77
Magnifying the Image ... 77
Erasing Images .. 78
Image Protection ... 79
TV Playback .. 80

Image Processing Settings 83
Picture Styles .. 85
Standard .. 85
Portrait .. 86
Landscape ... 86
Neutral ... 87
Faithful ... 87
Monochrome .. 88
User-Defined Picture Styles 91
Color Space .. 93
White Balance ... 93
White Balance Presets .. 95
Auto ... 95
Daylight .. 96
Shade ... 96
Cloudy .. 96
Tungsten Light ... 97
White Fluorescent Light 97
Flash .. 98
Custom White Balance ... 98
White Balance Correction 100
White Balance Auto Bracketing 102
White Balance and RAW 103
File Formats ... 104
Processing RAW Files ... 107
Image Size and Quality .. 108
Image Size and Card Capacity 111

Shooting Operations ... 113
Focus .. 113
 AF Modes ... 115
 One-Shot .. 116
 AI Servo .. 116
 AI Focus .. 116
 Selecting an AF Point ... 117
 Autofocus Limitations .. 118
Drive Modes and the Self-Timer .. 119
 Continuous Shooting .. 120
 Self-Timer/Remote Control ... 120
 Self-timer: 2 sec .. 120
 Self-Timer: Continuous .. 120
Exposure .. 122
 ISO .. 122
 Setting the ISO ... 123
 Auto ISO .. 124
 Metering .. 124
 Evaluative Metering .. 125
 Partial Metering .. 126
 Spot Metering ... 127
 Judging Exposure .. 127
 Highlight Alert .. 128
 Basic Zone Shooting Modes ... 131
 Full Auto ... 132
 Portrait ... 132
 Landscape .. 132
 Close-Up ... 133
 Sports ... 133
 Night Portrait ... 133
 Flash Off ... 134
 Creative Zone Shooting Modes 134
 Program AE Mode ... 134
 Shutter-Priority AE Mode .. 136
 Aperture-Priority AE Mode .. 140
 Automatic Depth-of-Field AE 141
 Manual Exposure Mode .. 142
 Bulb Exposure .. 143
 AE Lock ... 143
 Exposure Compensation .. 145

Autoexposure Bracketing (AEB) 146
Live View Shooting .. 148

Flash .. 153
Flash Synchronization ... 154
Guide Numbers ... 156
Built-In Flash .. 156
Flash Metering .. 158
Flash with Camera Exposure Modes 160
 Program AE .. 160
 Shutter-Priority AE ... 160
 Aperture-Priority AE ... 161
 Manual Exposure .. 162
 A-DEP .. 162
 FE (Flash Exposure) Lock 162
 Flash Exposure Compensation 164
Red-Eye Reduction .. 165
Canon Speedlite EX Flash Units 166
 Canon Speedlite 580EX II 167
 Canon Speedlite 430EX .. 170
 Other Speedlites ... 170
 Close-Up Flash ... 170
 Macro Twin Lite MT-24EX 170
 Macro Ring Lite MR-14EX 170
Bounce Flash ... 172
Wireless E-TTL Flash .. 173

Lenses and Accessories ... 175
Choosing Lenses ... 176
 EF-Series Lenses .. 178
 EF-S Series Lenses .. 179
 L-Series Lenses .. 181
 DO-Series Lenses .. 182
 Macro and Tilt-Shift Lenses 182
 Independent Lens Brands .. 183
Filters ... 184
 Polarizers ... 184
 Neutral Density Gray Filters 186

Graduated Neutral Density Filters 187
UV and Skylight Filters .. 188
Close-Up Lenses .. 188
Close-Up Sharpness ... 190
Close-Up Contrast .. 191
Tripods and Camera Support .. 194

Working with Files in the Computer 197
The Card Reader .. 198
Organizing Files in the Computer ... 199
Image Browser Programs ... 202
Image Processing .. 205
Digital Photo Professional Software 207
EOS Utility .. 209
Picture Style Editor ... 210
Storing Your Images ... 211
Direct Printing ... 213
Digital Print Order Format (DPOF) .. 216

Glossary .. 218

Index .. 223

Digital Photography: The Revolution Continues

Canon started the affordable digital SLR revolution when the original EOS Digital Rebel was introduced in 2003. For the first time, photographers could buy a digital SLR (D-SLR) for under $1,000 US. In 2005, Canon introduced the EOS Digital Rebel XT, improving on almost every aspect of the original Digital Rebel. Then in 2006, Canon presented the third generation, the Canon EOS Digital Rebel XTi. Continuing the revolution is the Canon EOS Rebel XSi, also known as the EOS 450D outside North America. With its introduction, Canon has continued to set the standard for affordable digital SLRs.

Introduced in January of 2008, the Canon Digital Rebel XSi's body measures only 5.1 x 3.8 x 2.4 inches (128.8 x 97.5 x 61.9 mm) and weighs just 16.8 ounces (475 g) without lens. Yet the Rebel XSi offers a newly developed 12.2 megapixel image sensor, along with additional features that compare favorably with cameras that come with a much higher price tag. The Rebel XSi does far more than simply replace the Digital Rebel XTi—it has improved many features, and includes new technology like Live View shooting, 14-bit analog-to-digital conversion, and Auto Lighting optimization.

With a high resolution sensor (12.2 megapixels) and in-camera processing options to adjust sharpness, color tone, and contrast, the EOS XSi brings extraordinary detail to your photos.

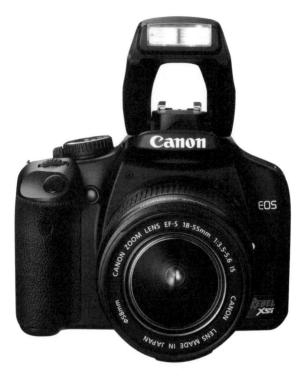

The EOS Rebel XSi is sold in both black and silver versions.

Some photographers have purchased the Digital Rebel XSi as an upgrade from the Canon EOS Digital Rebel, Rebel XT, or Rebel XTi. Others, however, are making their first high-quality digital camera investment. For those photographers new to digital SLR photography, this book begins with an assortment of basic topics and concepts. Experienced digital photographers and anyone already familiar with these terms and concepts should skip ahead to the detailed sections on camera operation, beginning on page 27.

As a matter of convenience (and easier reading), I usually refer to the Canon EOS Rebel XSi simply as the Rebel XSi or the XSi. As previously mentioned, outside of North America the same camera is known as the Canon EOS 450D.

Canon created the multi-featured Rebel XSi so it would meet the requirements of photographers of all levels of experience. While this book thoroughly explores all of the Rebel XSi's features, you certainly don't need to know how to operate every one of them. Once you understand what a feature does, you may decide it is not necessary to master it in order to achieve your desired photographic results. Learn the basic controls. Explore any additional features that work for you. Forget the rest. At some point in the future you can always delve further into this book and work to develop your Rebel XSi techniques and skills. Just remember that the best time to learn about a feature is before you need it.

Digital cameras do some things differently than traditional film cameras, making them exciting and fun to use, no matter whether you are an amateur or a pro. For digital beginners, many of these differences may seem complicated or confusing. Though most of the features found on a traditional Canon EOS film camera are also available on the Rebel XSi, there are many new controls and operations unique to digital. Other features have been added to increase the camera's versatility for different shooting styles and requirements. The goal of this guide is to help you understand how the camera operates so that you can choose the techniques that work best for you and your style of photography.

Differences between Digital and Film Photography

Just a few years ago it was easy to tell the difference between photos taken with a digital camera and those shot with a traditional film camera: Pictures from digital cameras didn't measure up in quality. This is no longer true. With the Rebel XSi, you can make prints of at least 16 x 20 inches (40.6 x 50.8 cm) that will match an enlargement from 35mm film.

Although there are differences between film and digital image capture, there are many similarities as well. A camera is basically a box that holds a lens that focuses light onto a

light sensitive frame, or medium. In traditional photography, the light sensitive frame is a piece of film that is later developed with chemicals. In digital photography, however, the light sensitive frame is the image sensor that converts the light to voltages. The camera then converts the voltages into digital data that represent the pixels that make up an image. In essence, unlike a film camera, a digital camera "develops" the image within the camera.

Film vs. the Sensor
Both film and digital cameras expose pictures using virtually identical methods. The light metering systems are based on the same technologies. The sensitivity standards for both film and sensors are similar, and the shutter and aperture mechanisms are basically the same. These similarities exist because both film and digital cameras share the same function: To deliver the amount of light required by the sensitized medium to create a picture you will like.

However, image sensors react to light differently than film does. From dark areas (such as navy blue blazers, asphalt, and shadows) to midtones (blue sky and green grass) to bright areas (such as white houses and snowy slopes), a digital sensor responds to the full range of light equally, or linearly. Film, however, responds linearly only to midtones. Therefore, film blends tones very well in highlight areas, whereas digital sensors often cut out at the brightest tones. Digital typically responds to highlights in the way that slide film does, and to shadows as does print film.

The LCD Monitor
One of the major limitations of film is that you really don't know if your picture is a success until the film is developed. You have to wait to find out if the exposure was correct or if something happened to spoil the results (such as the blurring of a moving subject or stray reflections from flash). The Rebel XSi features a large LCD monitor (3 inches; 7.62 cm) so you can review your image within seconds of taking the shot. Though you may not be able to see all the minute details on this small screen, the display provides a general

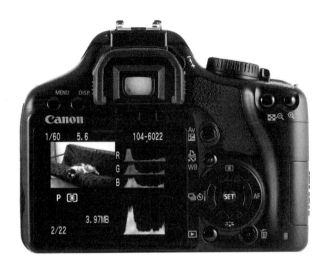

The LCD monitor is a valuable tool in digital photography, allowing you not only to review photos, but also to see all types of information about the settings and images, including the shutter speed, aperture, metering mode, and histograms.

idea of what has been recorded, so you can evaluate your pictures as soon as you shoot them.

The Histogram

Whether you shoot film or digital, the wrong exposure causes problems. Digital cameras do not offer any magic that lets you beat the laws of physics: Too little light makes dark images; too much makes overly bright images.

With traditional film, many photographers regularly bracket exposures (shoot the same image several times while changing settings, e.g. increasing or decreasing shutter speed or aperture on consecutive shots) in order to ensure they get the exposure they want. You can still bracket with digital if you want—the XSi can do it automatically for you—but there is less of a need because you can check your exposure as you shoot.

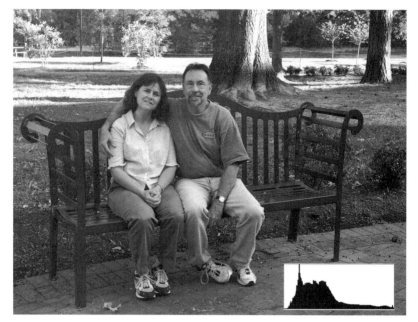

A histogram that stretches from left (dark tones) to right (light tones) and slopes to end at each axis will contain a full range of tones without clipping either shadows or highlights. © Kevin Kopp

The Rebel XSi's histogram function helps in this evaluation. This feature, which is unique to digital photography, displays a graph that allows you to immediately determine the range of brightness levels within the image you have captured (see page 129).

Film vs. Memory Cards

Images captured by a digital camera are stored on memory cards. These removable cards affect photographic technique by offering the following advantages over film:

More Photos: Standard 35mm film comes in two sizes: 24 and 36 exposures. Memory cards come in a range of capacities, and all but the smallest are capable of holding more exposures than film (depending on the selected file type).

Reusable: Once you make an exposure with film, you have to develop and store the negative and print. Due to a chemical reaction, the emulsion layer is permanently changed, so the film cannot be reused. With a memory card, you can remove images at any time, opening space for additional photos. This simplifies the process of organizing your final set of images. Once images are transferred to your computer (or another storage medium—burning a CD is recommended), the card can be reused.

Durability: Memory cards are much more durable than film. They can be removed from the camera at any time (as long as the camera is turned off) without the risk of ruined pictures. They can even be taken through the carry-on inspection machines at the airport without suffering damage.

No ISO Limitations: Digital cameras can be set to record at different light sensitivities or ISO speeds at any time. This means the card is able to capture images using different ISO settings, even on a picture-by-picture basis. With film, you must expose the entire roll before you can change sensitivity.

Small Size: In the space taken up by just a couple rolls of film, you can store or carry multiple memory cards that will hold hundreds of images.

Greater Image Permanence: The latent image on exposed, but undeveloped, film is susceptible to degradation due to conditions such as heat and humidity. With new security precautions at airports, the potential for film damage has increased. But digital photography allows greater peace of mind. Not only are memory cards durable, their images can also be easily downloaded to storage devices or laptops. This flexibility comes with a risk—the chance that images may be inadvertently erased—so make sure you make backups.

ISO

ISO is an international standard method for quantifying film's sensitivity to light. Once an ISO number is assigned to a film, you can count on its having a standard sensitivity, or

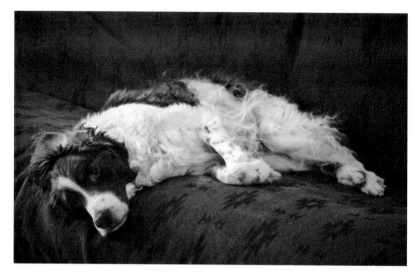

I can photograph my old dog Bucko indoors in low light using ISO 800, and then immediately lower ISO to 100 when I follow him outside to get some shots as he plays in the backyard.

speed, regardless of the manufacturer. Low numbers, such as 50 or 100, represent a relatively low sensitivity, and films with these speeds are called slow films. Films with high numbers, such as 400 or above, are more sensitive and are referred to as fast. ISO numbers are mathematically proportional to the sensitivity to light. As you double or halve the ISO number, you double or halve the film's sensitivity to light (i.e. 800 speed film is twice as sensitive to light as 400 speed, and it is half as sensitive to light as 1600 speed).

Technically, digital cameras do not have a true ISO. The sensor has a specific sensitivity to light. Its associated circuits change its relative "sensitivity" by amplifying the signal from the chip. For practical purposes, however, the ISO setting on a digital camera corresponds to film. If you set a digital camera to ISO 400, you can expect a response to light that is similar to ISO 400 film.

Unlike film, changing ISO picture-by-picture is easy with a digital camera. By merely changing the ISO setting, you use the sensor's electronics to change its sensitivity. It's like changing film at the touch of a button. This capability provides many advantages. For example, you could be indoors using an ISO setting of 800 so you don't need flash, and then you can follow your subject outside into the blazing sun and change to ISO 100. The Rebel XSi D-SLR offers an extremely wide range of ISO settings, from 100 to 1600.

Noise and Grain

Noise in digital photography is the equivalent of grain in film photography. It appears as an irregular, sand-like texture that, if large, can be unsightly and, if small, is essentially invisible. (As with grain, this fine-patterned look is sometimes desirable for certain creative effects.) In film, grain occurs due to the chemical structure of the light-sensitive materials. In digital cameras, noise occurs for several reasons: sensor noise (caused by various things, including heat from the electronics and optics), digital artifacts (when digital technology cannot deal with fine tonalities such as sky gradations), and JPEG artifacts (caused by image compression). Of all of these, sensor noise is the most common.

In both film and digital photography, grain or noise emerges when using high ISO speeds. And, on any camera, noise is more obvious with underexposure. With digital cameras, noise may also be increased with long exposures in low-light conditions. The Rebel XSi's new sensor gathers more light and has improved noise reduction circuitry to minimize digital noise. This technology gives the camera incredible image quality—at high ISOs with low noise—that simply wasn't possible in the past. This camera also has a number of technologies that create better images with long exposures.

File Formats

A digital camera converts the continuous (or analog) image information from the sensor into digital data. The data may be saved into either of two different digital file formats, RAW or JPEG.

One very useful feature of digital SLRs is their ability to capture a RAW file. RAW files are image files that include information about how the image was shot but have little processing applied by the camera. They also contain 14-bit color information, which is the maximum amount of data available from the sensor. (It is a little confusing that the RAW file format is actually a 16-bit file, though the data from the sensor is 14-bit.) The Rebel XSi uses the CR2 file, the same advanced RAW format developed for the Canon EOS-1D Mark II.

JPEG (Joint Photographic Experts Group) is a standard format for image compression and is the most common file created by digital cameras. Digital cameras use this format because it reduces the size of the file, allowing more pictures to fit on a memory card. It is highly optimized for photographic images.

Both RAW and JPEG files can produce excellent results. The unprocessed data of a RAW file can be helpful when you are faced with tough exposure situations, but the small size of the JPEG file is faster and easier to deal with. It is important to consider that a JPEG image might look great right out of the camera, while a RAW file may need quite a bit of adjustment before the image looks good. When in doubt, the XSi offers the option of recording both RAW and JPEG files of each image.

The Color of Light
Anyone who has shot color slide film in a variety of lighting conditions has horror stories about the color resulting from those conditions. Color reproduction is affected by how a film is "balanced" or matched to the color of the light. Our eyes adapt to the differences, but film does not.

In practical terms, if you shoot a daylight-balanced (outdoor) film while indoors under incandescent lights, your image will have an orange cast to it. For accurate color reproduction in this instance, you would need to change the film or use a color correction filter. One of the toughest pop-

ular lights to balance is fluorescent. The type and age of the bulbs affect their color and how that color appears on film, usually requiring careful filtration. Though filters are helpful in altering and correcting the color of light, they also darken the viewfinder, increase the exposure, and make it harder to focus and compose the image.

With digital cameras, all of this changed. A digital camera acts more like our eyes and creates images with fewer color problems. This is because color correction is managed by the white balance function. White balance is an internal setting built into all digital cameras, allowing them to use electronic circuits to neutralize whites and other neutral colors without using filters. This technology can automatically check the light and calculate the proper setting for the light's color temperature. White balance can also be set to specific light conditions, or custom-set for any number of possible conditions. Thanks to this technology, filters are rarely a necessity for color correction, making color casts and light loss a non-issue.

Digital Resolution

When we talk about resolution in film, we refer to the detail that the film can see or distinguish. Similarly, when referring to resolution in the context of lenses, we measure the lens' ability to separate elements of detail in a subject. With digital cameras, however, resolution indicates the number of individual pixels that are contained on the image sensor. This is usually expressed in megapixels. Each pixel captures a portion of the total light falling on the sensor. And it is from these pixels that the image is created. Thus, a 12-megapixel camera has 12 million pixels covering the sensor.

Dealing with Resolution: The Rebel XSi offers three different resolution settings from 3.4 to 12.2 megapixels. Although you don't always have to choose the camera's maximum resolution, generally it is best to use the highest setting available (i.e., get the most detail possible with your camera). You can always reduce resolution in the computer, but you cannot recreate detail if you never captured the data to

Using the camera's maximum resolution of 12.2 megapixels, the photo above can make a 16 x 20 inch print.

begin with. Keep in mind that you paid for the megapixels in your camera! The lower the resolution with which you choose to shoot, the less detail your picture will have. This is particularly noticeable when making enlargements. The Rebel XSi has the potential of making great prints at 16 x 20 inches (40.6 x 50.8 cm) and larger, but only when the image is shot at 12.2 megapixels.

Digital camera files generally enlarge very well in image editing programs, especially if you recorded them in RAW format first. (Recall that there is more data with which to work in the RAW format.) The higher the original shooting resolution, the larger the print you can make. However, if the photos are specifically for email or webpage use, you do not need to shoot with a high resolution in order for the images to look good on screen.

Remember, you can always reduce the resolution later in the computer. But you can't increase resolution without producing digital artifacts.

However, one advantage of high resolution images is the ability to crop and still have enough digital data to make sizeable prints. The single turkey will make a very nice 6 x 9 inch print.

Cost of Shooting

While film cameras have traditionally cost less than digital cameras, an interesting phenomenon is taking place that makes a digital camera a better overall value. Memory cards have become quite affordable. Once a card is purchased, it can be used again and again. Therefore, the cost per image decreases as the use of the card increases. Conversely, the more pictures you take with film, the more rolls you have to buy (and process), and the more expensive the photography becomes.

With digital cameras there is virtually no cost to shooting a large number of photos. The camera and memory card are already paid for, whether one, ten, or a hundred images are shot. This can be liberating because photographers can now try new ways of shooting, experiment with creative angles never attempted before, and so much more.

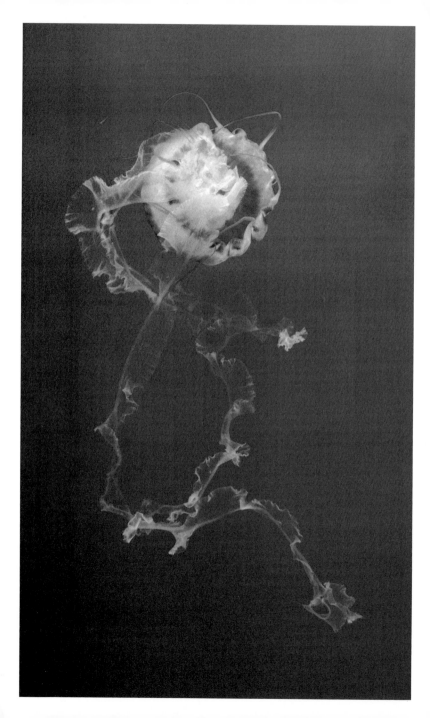

Features and Functions

In an effort to appeal to a broad spectrum of buyers, camera manufacturers equip today's cameras with many different features. You may find you do not need or will not use all of them. This book explains all the features on the Rebel XSi, and helps you master those that are most important to you. Don't feel guilty if you don't use every option packed into the camera. On the other hand, remember that you can't "waste film" with digital cameras. Shoot as much as you want and then erase those images that don't work. This means you can literally try out every feature, if you wish, on your camera to see how it functions. This is a quick and sure way of learning to use your camera, and it helps you determine which features really are most useful to you.

The Canon EOS Rebel XSi offers a high degree of technological sophistication at an affordable price. In many ways, it sets the bar for all other digital SLRs in this price range. With a sensor that contains 12.2 megapixels (MP), the Rebel XSi shoots 3.5 frames per second (fps) and up to 53 JPEG or 6 RAW frames consecutively. It also offers quick start-up, fast memory card writing speeds, and other controls that match the performance of many top pro cameras.

Built with a stainless steel chassis, the camera is housed in a polycarbonate body. While more expensive to manufacture, this construction creates a lightweight, yet strong, unit. The exterior of the camera is available in titanium silver or satin black finishes. Other than the finish color, there is no difference between the silver and black models.

The Rebel XSi focuses very quickly and there is little shutter lag—good news if you get an opportunity to capture a floating jellyfish before the composition changes or it moves farther away. © Marianne Wallace

Canon has used its EF-S lens mount for this camera. Intro-duced with the original Digital Rebel (EOS 300D), this mount accepts all standard Canon EF lenses. In addition, it accepts compact EF-S lenses, built specifically for small-for-mat sensors. EF-S lenses can only be used on cameras designed expressly to accept them.

Compared to the Rebel XTi, Canon engineers have re-designed the shape of the grip to improve camera handling. The Rebel XSi's display is larger and the layout of the user interface has been changed, creating a camera that is easier to use.

Note: When the terms "left" and "right" are used to describe the locations of camera controls, it is assumed that the camera is being held in horizontal shooting position.

Overview of Features

- Canon-designed and Canon-built 12.2 megapixel, small-format, APS-C sized CMOS sensor.
- Enlarged light-sensitive photosite areas, and redesigned micro lenses improve the light-gathering capability and signal-to-noise ratio.
- 14-bit analog-to-digital conversion for improved RAW file quality, and enhanced JPEG conversion.
- New, larger 3-inch (7.62 cm) color display that is brighter and sharper with auto-off sensor.
- Shoots 3.5 fps and up to 53 frames consecutively at max-imum JPEG resolution (6 frames continuous in RAW).
- Live View shooting mode with autofocus and exposure simulation.
- Integrated sensor cleaning system and Canon "Dust Delete Data" detection.
- Fast shutter lag time (about 0.09 seconds, the fastest of any digital Rebel yet produced).
- Six preset Picture Style settings and 3 user-defined cus-tom Picture Style settings.
- High-speed focal plane shutter, up to 1/4000 second with flash sync up to 1/200 second.

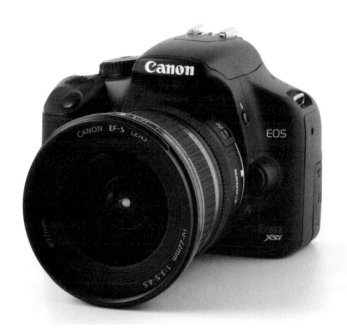

The Rebel XSi offers numerous enhancements over its predecessor, including a higher-resolution sensor, the improved DIGIC III processor, 14-bit analog/digital converter, and Auto Optimization to name a few.

- 9-point autofocus system.
- Easy access to AF (autofocus) points, menus, and other features via cross key system.
- User-activated noise subtraction for long exposures.
- Fully compatible with entire EOS system of lenses, flash, and other accessories.
- Flexible folder management system, with manual folder creation and up to 9,999 images per folder.
- Power-saving design promotes longer battery life.

EOS Rebel XSi – Front View

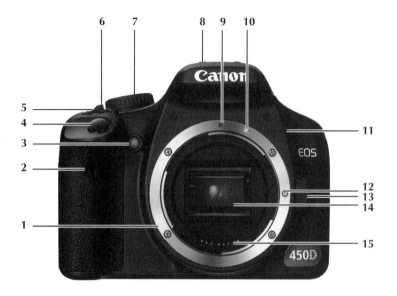

1. Lens mount
2. Remote control sensor
3. Red-eye reduction/
 Self-timer lamp
4. Shutter button
5. Main dial
6. Power switch (ON/OFF)
7. Mode dial

8. Built-in flash
9. EF lens mount index
10. EF-S lens mount index
11. Flash button
12. Lens lockpin
13. Lens release button
14. Mirror
15. Lens contacts

EOS Rebel XSi – Back View

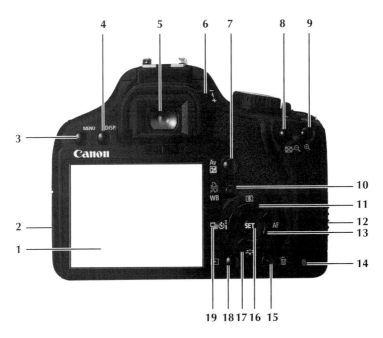

1. LCD monitor
2. Terminal cover
3. MENU button
4. Shooting display (DISP) button
5. Viewfinder
6. Diopter adjustment knob
7. Aperture/Exposure compensation button
8. FE lock/Index/ Reduce button
9. AF point selection/ Magnify button
10. Print/Share/ White balance button
11. Metering mode button/ Up cross key
12. Card slot cover
13. AF button/Right cross key
14. Access lamp
15. Erase button
16. SET button
17. Picture style button/Down cross key
18. Playback button
19. Drive mode button/ Left cross key

EOS Rebel XSi – Top View

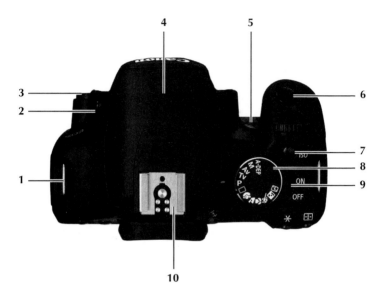

1. Strap mount
2. Flash button
3. Lens release button
4. Built-in flash/AF-assist beam
5. Red-eye reduction/Self-timer lamp

6. Shutter button
7. ISO button
8. Mode dial
9. Power switch
10. Hot shoe

Camera Controls

The EOS Rebel XSi uses icons, buttons, and dials common to all Canon cameras. Specific buttons are explained with the features they control.

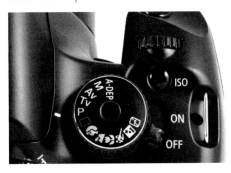

The Mode dial, behind the Main dial on the top right shoulder of the XSi, controls exposure settings.

Mode Dial

Located on top of the camera next to the power switch, the Mode dial is used to select various shooting modes. The 12 settings are grouped into two zones: Basic Zone and Creative Zone.

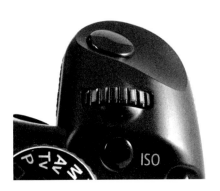

The Main dial is situated near the shutter button, allowing you to easily move it with your right index finger.

Main Dial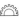

Behind the shutter button on the top right of the camera, the Main dial allows you to use your shooting finger to set things like exposure. The Main dial works alone when setting shutter speed and aperture. For a number of other

adjustments, it works in conjunction with buttons that are either pressed and released, or are held down while the Main dial is turned.

Shutter Button

The Rebel XSi features a soft-touch electromagnetic shutter release. Partially depressing the shutter button activates such functions as autoexposure and autofocus, but this camera is fast enough that there is minimal speed advantage in pushing the button halfway before exposure. It does help, however, when dealing with moving subjects to start autofocusing early, so the camera and lens have time to find your subject.

The four cross keys surround the Set button and allow you to navigate within the menu system. Each key also controls access to a specific camera function, marked by the icons for metering, autofocus, Picture Styles, and drive.

Cross Keys ✛

These four keys, arranged in a cross pattern with a centered Set button ⑤ , are located on the back of the camera to the right of the LCD monitor. As a group, the keys control navigation by allowing you to scroll up/down and left/right through menus. In addition, each key allows quick access to a specific menu item. When the camera is set for picture taking (no menu on the LCD), individual keys provide instant access to AF mode ▶AF , Picture Style selection ▼ ⁂, drive mode settings ◀☐/🕙 , and metering mode ▲ ⊙. When Live View shooting is enabled, the ⑤ button is used to turn on the "live view". ⑤ can also be programmed for various options using custom functions.

Press the MENU button to gain access to all seven menu tabs on the LCD monitor.

Menus Overview

The Digital Rebel XSi has several menus for setting up the operation of the camera. Once you press the **MENU** button, located on the back of the camera in the upper left corner, the menus display on the LCD monitor. The menu structure consists of seven menu tabs. (See pages 59-72 for more details about the XSi menus).

The first two tabs, color-coded red, are Shooting Menus 1 and 2: ◘ˑ and ◘ˑ . They deal with image capturing functions. The third tab (color-coded blue) is the Playback Menu ▣ˑ , which allows you to adjust options for displaying images on the LCD, and also controls image transfer and printing. The next three tabs, color-coded yellow, are Set-up Menus 1, 2, and 3: ⴽˑ , ⴽˑ and ⴽˑ . These deal with a variety of camera set-up functions. The last tab is My Menu ⵌ (color-coded green), enabling you to build your own set of menu options, customizing the XSi for your personal shooting needs. To navigate through the menu tabs after pressing **MENU**, use the Main dial ⚙ or the left/right cross keys ◀▶ .

If you are in one of the Basic Zone's shooting modes (see pages 131-134), the Shooting 2 ◘ˑ , Set-up 3 ⴽˑ and My Menu ⵌ menu tabs, as well as a few specific menu items, will not be available. As you continue through this book, if you can't find a menu item, check to see if the camera is in one of the Basic Zone's shooting modes.

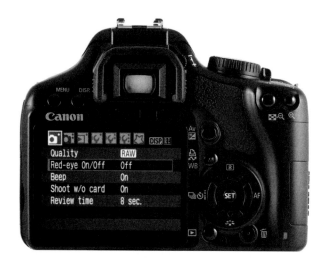

The menu system on the XSi, which displays in the LCD monitor, is a powerful tool for giving access to dozens of camera functions and settings. All of the options in Shooting Menu 1 are operable when the camera is in either the Basic Zone or the Creative Zone.

Note: When adjusting settings in the menus, be sure to press (SET) , located in the center of the cross keys, to accept the setting; otherwise the XSi reverts back to the earlier setting.

Camera Activation

The power switch is signified by ON and OFF inscribed on the top right of the camera.

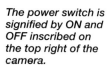

Power Switch

The power switch is found on the top right of the camera next to the Mode dial. In the ON position, this causes the camera to operate as long as the battery contains a charge.

Auto Power Off

All digital cameras automatically shut off after a period of inactivity to conserve power. The Rebel XSi has an <Auto power off> selection in the Set-up 1 Menu 🍴 that can be used to turn off the power after a set duration.

Auto power off is helpful to minimize battery use, but you may find it frustrating if you try to take a picture and find that the camera has shut itself off. For example, you might be shooting a hockey game and the action may stay away from you for a couple of minutes. If Auto power off is set to <1 min.>, the camera may be off as the players move toward you. When you try to shoot, nothing will happen because the camera is powering back up. You may miss the important shot. In this case, you might want to change the setting to <4 min.> or <8 min.> so the camera stays on when you need it.

You access the Auto power off function through the camera's menus. Press **MENU** and advance to the 🍴 Menu (color code yellow) using 🔄 . When 🍴 is highlighted, use the up/down cross keys ▲▼ to select <Auto power off>, the first option in this menu. You are given seven different choices ranging from 30 seconds to 15 minutes (including the <Off> option that prevents the camera from turning off automatically). Scroll with the cross keys to highlight the desired duration and press ⑤ to select it.

Resetting Controls

With all the controls built into the Rebel XSi, it is possible to set so many combinations that at some point you may want to reset everything. You can restore the camera to its original default settings by going to the Set-up 3 Menu 🍴 and selecting <Clear settings>, then pressing ⑤ . You can clear all camera settings or just the custom func-

Viewfinder

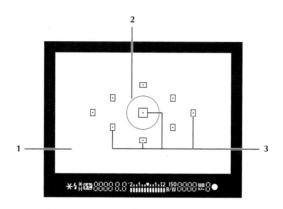

1. Focusing screen
2. Spot metering circle
3. AF points (total of nine)

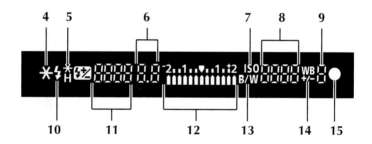

4. AE lock/AEB in progress
5. High-speed sync/FE lock/ FEB in progress
6. Aperture
7. ISO indicator
8. ISO speed
9. Maximum burst
10. Flash ready
11. Shutter speed/FEL/buSY/ Flash recycling/FuLL memory card/Card Err/ No card warning
12. Exposure indicator/ Exposure compensation scale/AEB range/Red-eye reduction lamp indicator
13. Monochrome shooting indicator
14. White balance correction
15. Focus confirmation indicator

tion settings (see pages 67-73). Also in this menu, you can check what version of firmware (the software that runs the camera) the camera uses.

The Viewfinder

The Rebel XSi uses a standard eye-level, reflex viewfinder with a fixed pentamirror. Images from the lens are reflected to the viewfinder by a quick return, semi-transparent half-mirror. The mirror lifts for the exposure, then rapidly returns to keep viewing blackout to a very short period. Viewfinder blackout time is about 130 milliseconds at 1/60 second or faster shutter speeds. (This is an improvement over the XTi's 170 ms.) The mirror is also dampened so that its bounce and vibration are essentially eliminated. The viewfinder shows approximately 95% of the actual image area captured by the sensor. The eyepoint is about 19 millimeters, which is good for people with glasses.

The viewfinder features a non-interchangeable, precision matte focusing screen. It uses special micro-lenses to make manual focusing easier and to increase viewfinder brightness. The viewfinder provides 0.87x magnification and includes superimposition display optics to make information easy to see in all conditions. The display includes a great deal of data about camera settings and functions, though not all these numbers are available at once. The camera's nine autofocus (AF) points are on the focusing screen, and the solid band at the bottom of the screen shows AE lock (auto-exposure lock), FE lock (flash exposure lock), flash information, exposure information, maximum burst, CF card information, white balance adjustment, and—new to the XSi—the current ISO sensitivity setting as well as whether you are shooting in Monochrome mode. Depth of field can be previewed through the viewfinder using the Depth-of-Field Preview button, located near the lens on the lower-left front of the camera.

There is no eyepiece shutter to block light entering the viewfinder when it is not against the eye (which affects exposure). However, an eyepiece cover, conveniently stored on the camera strap, is provided instead. It is necessary to remove the eyecup to attach the eyepiece cap.

Viewfinder Adjustment

The Rebel XSi's viewfinder features a built-in diopter (a supplementary lens that allows for sharper viewing). The diopter helps you get a sharp view of the focusing screen so you can be sure you are getting the correct sharpness as you shoot. For this to work properly, you need to adjust the diopter for your eye. The adjustment knob is just above the eyecup, slightly to the right. Fine-tune the diopter setting by looking through the viewfinder at the AF points. Then rotate the dioptric adjustment knob until the AF points appear sharp. You should not look at the subject that the camera is focused on, but at the actual points on the viewfinder screen. If you prefer, you can also use the information at the bottom of the screen for this purpose.

While some people can use this adjustment to see through the camera comfortably with or without eyeglasses, I have found that the correction isn't really strong enough for most who wear glasses regularly (like me).

The LCD Monitor

The LCD monitor is probably the one digital camera feature that has most changed how we photograph. Recognizing its importance, Canon has put a 3-inch (7.62 cm—quite large for digital cameras), high-resolution LCD screen in the monitor found on the back of the camera. With about 230,000 pixels, this screen has excellent sharpness, making it extremely useful for evaluating images.

You can adjust the brightness of the LCD monitor to any of seven levels. Press **MENU** and advance to highlight the tab for the Set-up 2 Menu **ℹ⁺** (color coded yellow) using

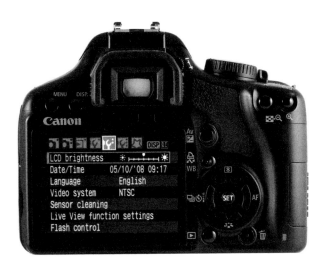

Not only does the LCD monitor let you review images you have recorded, but it gives you access to shooting information and to the vital menu system.

🔧 . Then use the up/down cross keys ▲▼ to select <LCD brightness> (the first menu option), and press ⚙ . The last image captured, together with a grayscale chart, appear on the LCD. A sliding scale appears that you can adjust with the left/right cross keys ◄► . Once you have selected the brightness setting you want, press ⚙ to confirm it and exit the Brightness setting menu screen.

The LCD monitor in the Rebel XSi can also display a graphic representation of exposure values, called a histogram (see page 76). The ability to see both the recorded picture and an exposure evaluation graph means that under and overexposures, color challenges, lighting problems, and compositional issues can be dealt with on the spot. Flash photography in particular can be checked, not only for correct exposure, but also for other factors such as the effect of lighting ratios when multiple flash units and/or

reflectors are used. No Polaroid film test is needed. Instead, you can see the actual image that has been captured by the sensor.

In addition, the camera can rotate images in the LCD monitor. Some photographers love this feature, others hate it, but you have the choice. The autorotate function (see page 77) displays vertical images properly without holding the camera in the vertical position—but at a price: The image appears smaller on the LCD. On the other hand, you can keep the image as big as possible by not applying this function, but a vertical picture will appear sideways in the LCD.

You can also magnify an image up to 10x in the monitor, and the enlarged photo is scrollable using the four cross keys ✛ so you can inspect all of it. While the image is magnified, you can use 🔄 to scroll back and forth through your other images. This way you can compare details in images without having to re-zoom on each one.

The shooting information display gives a summary view of the important camera settings.

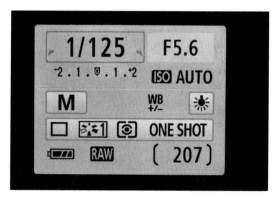

The LCD is not just for displaying images. It is designed to display shooting information and is always operational when the camera is on. When not in menu mode or playing back an image, the LCD shows the current camera settings: Exposure, white balance, drive settings, metering type, focusing type, resolution, and much more.

While this display is always available when the camera is on, a display-off sensor below the viewfinder turns off the display when you bring the camera up to your eye for shooting. This saves power and minimizes distraction when you look through the viewfinder. The sensor works by emitting infrared light that is reflected back to an infrared sensor by any object that passes close to the viewfinder. To save power, you can also turn off the display manually by using the Display button DISP. , located on back of the camera to the left of the viewfinder.

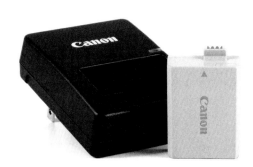

Canon has increased the capacity of the rechargeable battery, yet kept it small.

XSi Batteries

Canon has introduced a new battery for the XSi. At 1080mAh in capacity, the lithium ion LP-E5 battery is a great improvement over the XTi's 720mAh battery. Milliamp Hours (mAh) indicate a battery's capacity to hold a charge. Higher mAh numbers mean longer-lasting batteries.

Although the camera is designed for efficient use of battery power, it is important to understand that power consumption is highly dependent on how long features such as flash, autofocus, and the LCD are used. The more the camera is active, the shorter the battery life, especially with regard to use of the LCD and built-in flash. Be sure to have backup batteries. And it is always a good idea to shut the camera off if you are not using it.

Canon estimates that at 73°F (23°C), the battery will last approximately 600 shots when flash is not used, or 500 shots when flash is used 50% of the time. Lower temperatures reduce the number of shots. In addition, it is never wise to expose your camera or its accessories to heat or direct sunlight (i.e., don't leave the camera sitting in your car on a hot or a cold day!). When you use the Live View feature, the number of shots drops to 200, or 190 with 50% flash usage. The LP-E5 is rated at 7.4 volts and it takes about 2 hours to fully charge on the LC-E5 charger that is included with the camera.

The Battery Grip BG-E5 attaches to the bottom of the camera and can be used with one or two LP-E5 batteries. If two batteries are loaded, power is initially drawn from the battery having the higher voltage. Once the voltage level of the two batteries is the same, power is drawn from both packs.

The grip also has an adapter, BGM-E5A, which allows six AA-size batteries to be used. A nice feature of the battery grip is that the camera feels the same whether you shoot vertically or horizontally. The battery grip duplicates several controls on the camera so that they are just as easy to access. The duplicate controls include a shutter button, AE lock button ✱ , power switch, ⌂ , exposure compensation button Av☒ , and AF point selection button ⊞ , as well.

Note: There are a few limitations if you use AA batteries. The XSi will not let you do a manual cleaning of the image sensor. The battery indicator might incorrectly show that there is no (or little) power left in the batteries. Even so, a spare pack of Lithium AA batteries is good insurance in case your LP-E5s run out.

The AC Adapter Kit (ACK-E5) is useful to those who need the camera to remain consistently powered up (i.e., for scientific lab work). You can charge the battery in the car using the CBC-E5 12V charger.

Date/Time

Date and time are established by going to the Set-up 2 menu ⚙ . Next use ▲▼ to select <Date/Time>. Press ⚙ to enter the adjustment mode. Once there, use ◄► to step through each parameter on the screen. When you are on a setting, press ⚙ to enter the adjustment mode and use ▲▼ to adjust the value. Press ⚙ again to accept the setting. Continue using the cross keys and ⚙ to adjust the date, time, and/or format the date/time display. Once the date and time are correct, use the cross keys to highlight <OK> and press ⚙ again to confirm your selections and exit the adjustment mode.

A special rechargeable battery inside the battery compartment holds the date and time memory even when you remove the LP-E5 battery. This special battery gets its recharge power from the LP-E5.

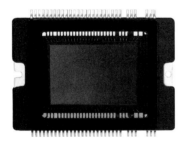

The sensor in the Rebel XSi is built with many of the same technologies found in Canon's professional EOS-1D Mark III D-SLR.

The Sensor

The Rebel XSi has a newly designed 12.2 megapixel sensor (4272 x 2848 pixels), which is remarkable in a camera of this class, especially given the Rebel XSi's price and speed. It can easily be used for quality magazine reproduction across two pages.

Because the Rebel XSi's APS-sized CMOS sensor (22.2 x 14.8 mm; APS stands for Advanced Photo System) covers a

smaller area (small-format sensor) than a 35mm film frame, it records a narrower field of view than a 35mm film camera. To help photographers who are used to working with 35mm SLRs visualize this narrower field of view, a cropping factor of 1.6 is applied to the lens focal length. Thus, on the Rebel XSi, a 200mm lens has a field of view similar to that of a 320mm lens on a 35mm camera. Remember, the focal length doesn't change, just the view seen by the Rebel XSi's sensor.

This focal length conversion factor is great for telephoto advocates because a 400mm telephoto acts like a 640mm lens on a 35mm camera. However, at the wide-angle end a lens loses most of its wide-angle capabilities, where a 28mm lens acts like a 45mm lens, for example. But since the Rebel XSi accepts Canon EF-S lenses (see page 179), which are specially designed for this size image sensor, you can use the Canon 10-22mm zoom if you want to shoot wide-angle pictures, because that offers an equivalent 16-35mm focal length.

Though small-format, the sensor in the Rebel XSi demonstrates improvements in sensor technology. It adds nearly 20% more pixels than the Rebel XTi, on the same size image sensor. So obviously each pixel has to be smaller. In the past, this would have meant problems with noise, sensitivity, dynamic range, and reduced continuous shooting speed. However, this sensor's 12.2 megapixels offer the same signal-to-noise, ISO range, and dynamic range as the XTi. And despite the larger number of pixels, the continuous shooting speed for JPEG images has also increased.

Low noise characteristics are extremely important to advanced amateur and professional photographers who want the highest possible image quality. The Rebel XSi gives an extraordinarily clean image with exceptional tonalities and it can be enlarged with superior results.

Several other factors contribute to the improved imaging quality. Canon has worked hard on the design and produc-

tion of its sensors. (They are one of the few digital SLR manufacturers that make their own sensors.) The microlens configuration has been improved to increase light-gathering ability, improve light convergence, and reduce light loss. The area that is sensitive to light on each pixel has also been increased.

In addition, the camera has an improved low-noise, high-speed output amplifier as well as power-saving circuitry that also reduces noise. With such low noise, the sensor offers more range and flexibility in sensitivity settings. ISO settings range from 100-1600.

The on-chip RGB primary color filter uses a standard Bayer pattern over the sensor elements. This is an alternating arrangement of color with 50% green, 25% red, and 25% blue; full color is interpolated from the data. In addition, an infrared cut-off, low-pass filter is located in front of the sensor. This two-part filter is designed to prevent the false colors and the wavy or rippled look of surfaces (moiré) that can occur when photographing small, patterned areas with high-resolution digital cameras.

Mirror Lockup

For really critical work on a tripod, such as shooting long exposures or working with macro and super telephoto lenses, sharpness is improved by eliminating the vibrations caused by mirror movement. This is accomplished by locking up the mirror in advance using the Rebel XSi's mirror lockup function. However, it also means the viewfinder is blacked out and the drive mode is Single shooting.

Mirror lockup is set with Custom Function 9 (C.Fn-9, see page 70). Once set, the mirror locks up when the shutter button is pressed. Press the shutter button again to make the exposure. The mirror flips back down if you don't press the shutter within 30 seconds.

Mirror lockup prevents blur caused by camera motion when the mirror flips up to expose the sensor. This is an important setting when doing macro photography.

Use a remote switch or the self-timer to keep all movement to a minimum. With the self-timer, the shutter goes off two seconds after the mirror is locked up, allowing vibrations to dampen. When you use the self-timer with Bulb exposure and mirror lockup, you must keep the shutter depressed during the two-second self-timer countdown, otherwise you will hear a shutter sound but the image will not be captured.

Memory Cards

The Canon EOS Rebel XSi uses Secure Digital (SD) memory cards. You need a sizeable card to handle the image files of this camera; anything less than 512 MB fills up too quickly (see page 111 for specifics). SD cards are sturdy, durable, and difficult to damage. One thing they don't like is heat; so make sure you store them properly.

This SDHC memory card is the same size as an SD card, yet the small SDHC logo signifies that it will work only in SDHC-supported devices.

There are actually two different kinds of SD cards: SD and SD high capacity (SDHC). The XSi supports both cards, but it is important to know the difference when you start downloading your images to the computer. An SDHC card fits into an SD slot, and other than the distinction in logos, it is impossible to visually tell the difference between the two styles. (The regular SD card was developed first; SDHC came later, offering larger capacities.)

The capacity difference between SD and SDHC doesn't affect the Rebel XSi. However, SDHC cards cannot be used in older SD devices, such as card readers or printers. If you deliver an SDHC card directly to someone for printing rather than printing your images yourself, make sure they can use an SDHC memory card. Likewise, if you have older SD devices, they will not support SDHC.

SDHC-capable slots, including the one in the Rebel XSi, have no problem using regular SD cards. This simple rule applies: SDHC-capable devices can use either SD or SDHC cards and SD devices can only use SD cards. Remember to look for the SDHC label on all your devices if you plan to use SDHC.

Note: Be wary of SD cards that are greater than 2GB but don't have the SDHC icon. They may not be reliable.

To remove the memory card from your camera, simply open the card slot cover on the right side of the body. Press gently on the edge of the memory card to release it from the camera. Carefully grab the edge of the card to remove it.

Caution: Before removing the memory card, it is a good idea to turn the camera off. Even though the Rebel XSi automatically shuts itself off when the memory card door is opened, make sure the access lamp on the back of the camera near the bottom right is not illuminated or flashing. This habit of turning the camera off allows the camera to finish writing to the card. If you should open the card slot and remove the card before the camera has written a set of files to it, there is a good possibility you will corrupt the directory or damage the card. You may lose not only the image being recorded, but also potentially all of the images on the card.

Warning: Don't take pictures with very low battery power. If you should lose power while the camera is writing to the card, the entire card could become corrupted, making it nearly impossible to read any files on the memory card.

You have three choices in how the camera numbers the images on the card. They can go continuously from 0001 to 9999, even when you change cards (Continuous). Or, the camera can reset numbers every time you change cards (Auto reset). Lastly, you can manually reset the numbering (Manual reset).

The continuous file numbering option stores all of the images in one folder on the card. Once image 9999 is recorded, the camera tells you that you need to replace the card. At that point you have to replace the SD card or change the numbering options.

Note: Even if you delete images, the maximum number for an image is 9999.

When you use the Auto reset option, numbering is reset to 0001 and a new folder is created each time the memory card

is inserted into the camera. The Manual reset option allows you to immediately create a new folder and reset the file numbering to 0001 without having to remove and re-insert the memory card. The maximum number of folders is 999. At 999, you get a "Folder number full" message on the LCD.

There is no advantage to a particular method of numbering; it is a personal preference depending on how you want to manage your images. Continuous numbers can make it easy to track image files over a specific time period. Creating folders and resetting numbers lets you organize a shoot by location or subject matter. To select Continuous, Auto reset, or Manual reset, go to **I'** and select <File numbering>.

Formatting Your Memory Card

Before you use a memory card in your camera, it must be formatted specifically for the Rebel XSi. To do so, go to **I'** and then use **▲▼** to highlight <Format>. Press ⓈⒺⓉ and the Format Menu appears on the LCD. It tells you how much of the card is presently filled with images and how big the card is. Use ✛ to move the choice to <OK>, press ⓈⒺⓉ , and formatting begins. You will see a screen showing the progress.

Caution: Formatting your memory card erases all images and information that has been stored there, including protected images. Be sure that you do not need to save anything on the card before you format. (Transfer important images to a computer or other downloading device before formatting the card.)

The format screen also gives the option of performing a low level format of the card. Low level formatting rebuilds the card's file structure and flags any memory locations that are unreliable. While low level formatting takes more time, it is a good idea to do this on a relatively frequent basis. Press the Erase button 🗑 , located on the back of the camera in the lower right corner, to put a check mark in the Low level format box.

Even though the XSi has a self-cleaning sensor that operates automatically whenever you turn the camera on or off, you should still take precautions to keep your camera, sensor, and lenses as clean as possible. Be especially careful in dusty, sandy, and windy conditions. © Kevin Kopp

It is important to routinely format a memory card to keep its data structure organized. However, never format the card in a computer. A computer uses different file structures than a digital camera and may either make the card unreadable for the camera or may cause problems with your images.

Cleaning the Camera

A clean camera minimizes the amount of dirt or dust that could reach the sensor. A good kit of cleaning materials should include the following: A soft camel hair brush to clean off the camera, an antistatic brush and micro-fiber cloth for cleaning the lens, a pack towel for drying the camera in damp

conditions (available at outdoor stores), and a small rubber bulb to blow debris off the lens and the camera.

Always blow and brush debris from the camera before rubbing with any cloth. For lens cleaning, blow and brush first, then clean with a micro-fiber cloth. If you find there is residue on the lens that is hard to remove, you can use lens-cleaning fluid, but be sure it is made for camera lenses. Never apply the fluid directly to the lens, as it can seep behind the lens elements and get inside the body of the lens. Apply with a cotton swab, or just spray the edge of your micro-fiber cloth. Rub gently to remove the dirt, and then buff the lens with a dry part of the cloth, which you can wash in the washing machine when it gets dirty.

You don't need to be obsessive, but remember that a clean camera and lens help ensure that you don't develop image problems. Dirt and residue on the camera can get inside when changing lenses. If these end up on the sensor, you will have image problems. Dust on the sensor appears as small, dark, out-of-focus spots in the photo (most noticeable in light areas, such as sky). You can minimize problems with sensor dust if you turn the camera off when changing lenses (preventing a dust-attracting static charge from building up). Keep a body cap on the camera and lens caps on lenses when not in use. You should regularly vacuum your camera bag so that dust and dirt aren't stored with the camera.

The XSi has a built-in system to combat the dust that is inherent with cameras that use removable lenses. This system uses a two-prong approach: (1) The camera self-cleans to remove dust from the sensor, and (2) it employs a dust detection system to remove dust artifacts from images using software on your computer.

The low-pass filter in front of the sensor is attached to a piezoelectric element that rapidly vibrates at camera power-up and power-down. While self-cleaning at power up just before taking pictures seems like an obvious time to clean

This screen appears in the LCD whenever the automatic sensor cleaning is active. However, you can interrupt sensor cleaning to shoot a picture, if needed, simply by pressing the shutter button.

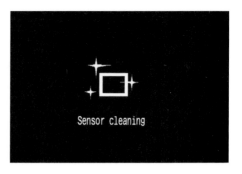

Sensor cleaning

the sensor, why clean it at power down? Cleaning at power-down prevents dust from sticking to the sensor when the camera sits for long periods of time.

Self-cleaning can be enabled and disabled under Ⓨ . Use ▲▼ to highlight <Sensor cleaning> and press ⓢⒺⓉ . In the Sensor cleaning submenu, select <Auto cleaning ⌐ > and press ⓢⒺⓉ . From there you can choose to <Enable> or <Disable> self-cleaning, then press ⓢⒺⓉ to accept your selection. You can also engage the self-cleaning function immediately or start the manual sensor cleaning procedure (see next page).

Note: In order to prevent overheating, the self-cleaning operation cannot be engaged within three seconds of any other operation. It also stops working if it is run five times within 10 seconds. After a brief delay (usually 10 seconds) it will be available for use.

In the event that there is still dust on the sensor, the Rebel XSi's Dust Delete Data feature can be used. By photograph-ing an out-of-focus, solid white object (such as a white sheet of paper), the image sensor is able to detect the shadow cast by dust stuck to the low-pass filter. Coordinates of the dust are embedded in the image metadata. Canon's Digital Photo Professional version 3.3 (supplied with the XSi) can use this data to automatically remove the dust spots in the image.

Manually Cleaning the Sensor

The Rebel XSi allows you to clean the sensor, but there are precautions to be taken. You must do this carefully and gently, indoors and out of the wind—and at your own risk! Your battery must be fully charged so it doesn't fail during cleaning (or you can use the optional AC adapter). The sensor unit is a precision optical device, so if the gentle cleaning described below doesn't work, you should send the camera to a Canon Service Center for a thorough cleaning.

To clean the sensor manually, turn the camera on and go to ⚐ . Using ▲▼ , highlight <Sensor cleaning> and press ⑤ . Use ▼ in the Sensor cleaning submenu to highlight <Clean manually> and press ⑤ , then follow the instructions. You'll see options for <OK> and <Cancel>. Using ▶ , highlight <OK> and press ⑤ . The LCD turns off, the mirror locks up, and the shutter opens. Take the lens off. Then, holding the camera face down, use a blower to gently blow any dust or other debris off the bottom of the lens opening first, and then blow off the sensor. Do not use brushes or compressed air because these can damage the sensor's surface. Turn the camera off when done. The mirror and shutter will return to normal. Put the lens back on.

Caution: Canon specifically recommends against any cleaning techniques or devices that touch the surface of the imaging sensor. Also, never leave a digital SLR without a body cap for any length of time. Lenses should be capped when not in use and rear caps should always be used when a lens is not mounted. Also, make sure you turn off the camera when you change lenses. These practices help to prevent dust from reaching the sensor.

Getting Started in 10 Basic Steps

There are ten things you can check in order to make your work with the camera easier from the start. These steps are especially useful if you have not yet become familiar with the camera. You will probably modify them with experience.

1. **Set <Auto power off> for a reasonable time:** The default duration in the ⚙ is just 30 seconds. I guarantee this will frustrate you when the camera has turned itself off just as you are ready to shoot. Perhaps it is more realistic to try <4 min.>. (See page 62.)

2. **Adjust the eyepiece:** Use the dioptric adjustment knob to the right of the viewfinder to make the focus through your eyepiece as sharp as possible. You can adjust it with a fingertip. (See page 40.)

3. **Customize the** ⑤ⓔⓣ **button:** Use Custom Function 11 to program ⑤ⓔⓣ to quickly access one of several key camera settings, such as image quality or flash exposure compensation. (See page 71.)

4. **Choose an image quality of** ◢L **or** ◢L **:** This determines your image size and recording quality. Select ◘ , then press ⑤ⓔⓣ and use the cross keys to select your desired image size (see page 108), but you are usually best served by choosing one of the high-quality options.

5. **Set your preferred shooting mode:** Use the Mode dial ⊙ on the top right shoulder of the camera to select any of the Basic Zone (see pages 131-134) or Creative Zone settings (see pages 134-143.) If using any of the Creative Zones, select a Picture Style. (See pages 85-92.)

6. **Select a drive mode:** Drive mode is selected by pressing the ◀⚊/⏱ key (this is also the ◀ cross key, located just to the right of the LCD) when a menu isn't being displayed. Select either Single shooting ☐ ,

Continuous shooting 🔳 , Self-timer/remote control 🕐 , Self-timer: 2 sec 🕐2 or Self-timer: Continuous 🕐c . (See pages 119-121.) The LCD indicates the drive mode the camera is in.

7. **Choose AF mode:** Autofocus (AF) mode is set by pressing the ►AF key, located to the right of ⚙ , when a menu isn't displayed on the LCD. The LCD monitor then displays several AF mode options. The selected mode displays in the camera settings on the LCD. A good place to start on this camera is AI Servo AF. (See page 116.)

8. **Select white balance (WB):** Auto white balance 🔲 is a good place to start because the Rebel XSi is designed to generally do well with it. To set, press the Print/Share/White Balance button 🔲 / WB located to the right of the LCD. (See pages 95-98.) The different white balance choices display on the monitor. After making your choice, the selected white balance appears in the camera settings display on the LCD.

9. **Pick an ISO setting:** Though any setting between 100 and 400 works extremely well, you can generally set higher ISO sensitivity with the Rebel XSi than with other digital cameras while showing less noticeable noise. (See pages 122-124.) The ISO values you set appear in the information display at the bottom of the viewfinder. You can even change ISO without having to take your eyes away from the viewfinder by using 🔲 to rotate through the ISO choices.

10. **Set camera for reasonable review time:** The default review time on the LCD monitor is only two seconds. That's very little time to analyze your photos, so I recommend the eight-second setting, which you can always cancel by pressing the shutter button. If you are worried about using too much battery power, just turn off the review function altogether. (See page 60.)

The Menu System and the LCD Monitor

Using the Menus

Menus systems and LCD monitors are two extremely important features that help define digital cameras. In fact, menus in D-SLRs are the indispensable means used to control the great number of settings found in these sophisticated cameras. Still, in some cameras, menus are a necessary evil because they are not always easy to use. Canon has put a great deal of thought into the design of the Rebel XSi's menus so that they can be used efficiently.

All menu controls, or items, are found in seven menus, grouped into four categories based on their use. These categories, intuitively named in order of appearance within the menu system, are Shooting ◘ , Playback ▣ , Set-up ʏ , and My Menu ♉ . You gain access to the Rebel XSi's menu selections whenever you push the Menu button **MENU**, located on the back of the camera above the top left corner of the LCD monitor. Once the menus are displayed, you can shift from category to category in one of two ways: use the Main dial ⚙ , located on the top of the camera just behind the shutter button, or use the left/right cross keys ◀▶ on the back of the camera.

⟲ *Understanding the XSi menus is an important key to activating functions and making adjustments so you can control your photography and capture great images.*

The menus are designated by their icon tabs at the top of the menu screen on the LCD monitor. In general, press MENU to display these different tabs. Scroll to highlight your desired menu by using ◄► , then press the Set button ⑤ET (on the back of the camera in the center of the cross keys) and you will see choices under the menu tab. Use ▲▼ to highlight a choice and confirm (lock-in) your selection with ⑤ET . Some items have further options to choose from, which require you to scroll and select in a similar manner, using the cross keys, ▲ ▼ ◄ ► , and ⑤ET . To back out of a menu, press MENU. Understanding the menu system is necessary in order to fully benefit from using the LCD monitor and the Custom Functions.

Note: When the camera is first used, pressing MENU takes you to the Shooting 1 Menu 📷' . After that, pressing MENU takes you to the last menu you selected.

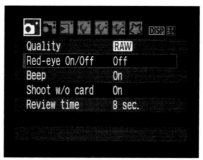

Shooting 1 Menu 📷' (Red)
For items that obviously affect actual photography, these two red-coded menus include a number of choices:

\<Quality\>	Sets image quality and resolution, plus selects RAW.
\<Red-eye On/Off\>	Sets red-eye reduction.
\<Beep\>	Audible signal for focus and self-timer.
\<Shoot w/o card\>	Allows you to test the camera when no memory card is installed.
\<Review time\>	Controls how long image stays on LCD monitor after shot.

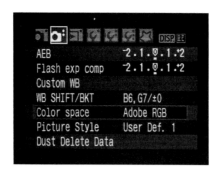

Shooting 2 Menu 📷 * (Red)

<AEB> Autoexposure bracketing.
<Flash exp comp> Adjusts flash exposure.
<Custom WB> Manually sets white balance.
<WB SHIFT/BKT> Used for bracketing and shifting
 white balance.
<Color space> sRGB or Adobe RGB.
<Picture Style> Sets up different profiles for pro-
 cessing images in-camera.
<Dust Delete Data> Captures reference file for dust
 extraction.

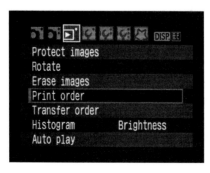

Playback Menu ▶ * (Blue)

This blue-coded menu offers several choices for use when viewing images on the LCD monitor.

<Protect images> Prevents images from being erased.
<Rotate> Rotates image so vertical pictures
 display vertically.

\<Erase images\>	Permanently erases multiple or all images on memory card.
\<Print order\>	Specifies images to be printed DPOF.
\<Transfer order\>	Used to select images for transfer to the computer.
\<Histogram\>	Selects between Brightness and RGB histograms.
\<Auto play\>	Automatic "slide show" on LCD monitor changes image every three seconds.

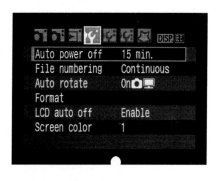

Set-up 1 Menu (Yellow)

Color coded yellow, the three set-up menus present selections to make before shooting.

\<Auto power off\>	Six options for different time periods, as well as no power off.
\<File numbering\>	Three different options for managing your image files.
\<Auto rotate\>	Controls when a vertical image is rotated in the camera and in the computer, only in the computer, or not rotated.
\<Format\>	Initializes and/or erases the memory card; very important.
\<LCD auto off\>	Selects whether or not to turn LCD off when eye approaches viewfinder.
\<Screen color\>	Changes the color of the shooting settings display.

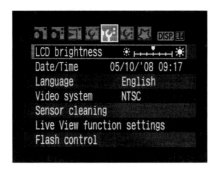

Set-up 2 Menu (Yellow)

<LCD brightness> Contains five levels of viewing
 brightness.

<Date/Time> Adjusts date and time that is
 recorded with images.

<Language> Options for setting your camera in
 20 different languages.

<Video system> NTSC or PAL.

<Sensor cleaning> Enables the auto cleaning function,
 which allows you to clean the sen-
 sor at any time automatically, or
 permits you to clean it manually.

<Live View function Enables Live View, turns on grid for
settings>* Live View composition, sets meter
 timer.

<Flash control>* Sets functions of built-in and exter-
 nal Canon EX flash units.

63

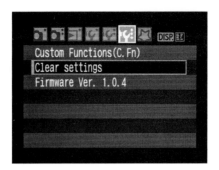

Set-up 3 Menu ꙮ * (Yellow)

<Custom Functions
(C.Fn)> Allows you to customize camera
 settings.

<Clear settings> Returns camera settings to factory-
 set defaults.

<Firmware Ver.> Used when updating the camera's
 software.

My Menu ✧ * (Green)

<My Menu settings> Provides access to menu items so
 you can customize a group of fre-
 quently used settings for quick
 access.

* *Note:* The items with an asterisk are not available in the
Basic Zone shooting modes, in which the camera controls
most all settings. See pages 131-134.

Using My Menu

When you first use the Rebel XSi, the My Menu display only has one selection, called <My Menu settings>. Through this selection you can build a custom menu using any of the top-level choices in any of the menus, as well as the Custom Functions Menu tab. My Menu can contain up to six selections.

To build a menu, first press **MENU** and move to the ☆ tab. Highlight <My Menu settings>, and then press ⑤⑤ . On the My Menu settings submenu, scroll to highlight <Register> and press ⑤⑤ again. A list of every top-level menu option, including custom functions, is displayed.

Note: Any previously assigned menu options are grayed out.

Now scroll to select the desired option and press ⑤⑤ again. Highlight <OK> and press ⑤⑤ to confirm the addition of the selected option to ☆ . Repeat the process until you have selected the options you want, up to a maximum of six. Press **MENU** to exit the selection screen, then press **MENU** again to see the resulting My Menu.

The My Menu submenu also allows you to sort your menu items once you've added them to the menu. Select <Sort> from the My Menu settings submenu and press ⑤⑤ . <Sort My Menu> is displayed, showing the current order of your menu items. Scroll to highlight an item you wish to move. Press ⑤⑤ and an up/down arrow icon appears to the right of the item. Use ▲▼ to move the item up or down in the list. Press ⑤⑤ once the item is in the preferred position and either repeat these steps to change the position of other items, or press **MENU** to exit Sort My Menu.

If you have filled ☆ with six items, you must delete an item before you can insert a new one—there is no exchange function. Highlight <Delete> in the My Menu settings submenu and press ⑤⑤ , then move to highlight an item you wish to delete. Press ⑤⑤ and a dialog asks you to confirm the deletion. Highlight <OK> and

65

No matter what settings you have currently applied to your XSi, you can quickly access your most consistently used menu and Custom Function selections with My Menu. For instance, you may want to bracket the exposure of certain landscapes, or lock up the mirror for longer exposures. © Kevin Kopp

press ⓢⒺⓣ . Repeat this process if you wish to delete other My Menu items, then press **MENU** to exit the Delete My Menu screen. Similarly you can select <Delete all items> to start with an empty My Menu.

You can customize your Rebel XSi so that ⭐ is displayed every time you press **MENU** (no matter which menu you were last on). To do so, highlight <Display from My Menu> in the My Menu settings screen. Press ⓢⒺⓣ , then highlight <Enable>, and press ⓢⒺⓣ .

Custom Functions (C.Fn)

Like most sophisticated D-SLRs, the Rebel XSi can be customized to fit the unique style and personality of a photographer. Of course, the selection of exposure modes, type of metering, focus choice, drive speed, Picture Style, and so forth, tailor the camera to a specific photographer's needs. However, the Rebel XSi allows for further customization and personalization to help the camera better fit your method and approach to photography. This is done through the Custom Functions (C.Fn) Menu. Some photographers never use these settings, while others use them all the time. The camera won't take better photos when you change these settings, but Custom Functions may make the camera easier for you to use.

The Rebel XSi has 13 different built-in Custom Functions, numbered 1-13. They are organized into four groups: C.Fn I: Exposure; C.Fn II: Image; C.Fn III: Auto focus/Drive; and C.Fn IV: Operation/Others.

Custom Functions are found in ⊮‡ . Select <Custom Functions (C.Fn)>, then press (SET) to enter the Custom Functions screen. Once there, navigate to the desired Custom Function (function numbers are displayed at the bottom of the LCD monitor), and again press (SET) . Highlight the option you want to use and press (SET) to accept. To exit the Custom Function Menu, press **MENU**.

A summary and commentary on the various Custom Functions is found on the following pages. Note that the first selection in each Custom Function is the default setting for the camera.

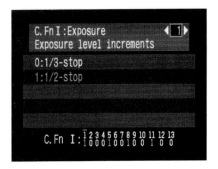

C.Fn I: Exposure
1 Exposure level increments

This sets the size of incremental steps for shutter speeds, apertures, exposure compensation, and autoexposure bracketing (AEB).

0: <1/3 stop> The increment is 1/3 stop.

1: <1/2 stop>

2 Flash sync speed in Av mode

This setting controls the camera-selected flash-sync speed in Av mode.

0: <Auto> The camera varies the shutter speed to match the ambient light conditions.

1: <1/200sec. (fixed)> The camera always uses 1/200 second in Av mode. This Custom Function doesn't seem to be particularly useful, since using Manual exposure (M) mode at 1/200 and then changing the f/stop gives you the same feature, but without going through the menu.

C.Fn II: Image
3 Long exposure noise reduction

This setting engages automatic noise reduction for long exposures. When noise reduction is used, the processing time of the image is a little more than twice the original exposure. For example, a 20-second exposure takes an additional 20 seconds to complete.

0: <Off> Long exposure noise reduction is turned off.

1: <Auto> Noise reduction is turned on if the exposure

is 1 second or longer and noise common to long exposures is detected.

2: <On> Noise reduction is turned on for all expo-
 sures.

4 High ISO speed noise reduct'n

As you increase the apparent sensitivity of the XSi by using high ISO settings, you increase the noise in the image. This Custom Function helps to reduce that noise. When set to <On>, it decreases the number of shots that can be captured in a row, and white balance bracketing is turned off.

0: <Off >
1: <On>

5 Highlight tone priority

This is one of the Rebel XSi's more interesting Custom Functions. Enable this option to expand dynamic range near the bright area of the tone curve. When enabled, the ISO speed range is 200-1600.

0: <Disable>
1: <Enable>

Note: When the XSi has highlight tone priority enabled, the ISO speed setting readouts in the viewfinder and on the LCD monitor use small 00's, i.e. 2oo versus 200.

6 Auto Lighting Optimizer

In difficult exposure situations where the scene is dark and this function is enabled, the XSi automatically adjusts the brightness and contrast of the image. In Basic shooting modes, the optimizer is engaged automatically.

0: <Enable>
1: <Disable>

Note: This setting has no effect when shooting 🅡🅐🅦 , 🅡🅐🅦 + ▲L or Manual exposure modes.

69

C.Fn III: Auto focus/Drive
7 AF-assist beam firing

This controls the AF-assist beam, which is useful when using autofocus in low-light situations. (See page 114.).

0: <Enable> The AF-assist beam is emitted whenever appropriate.

1: <Disable> This cancels the AF-assist beam.

2: <Only external flash emits> In low light, an accessory EX flash unit fires its AF-assist beam. The built-in flash's AF-assist feature is disabled.

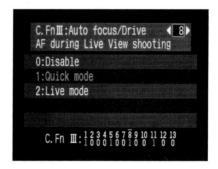

8 AF during Live View shooting

Since the normal AF sensors are located in the viewfinder, they are blocked during Live View shooting. This Custom Function is used to decide how to achieve autofocus during live shooting.

0: <Disable> AF is not performed.

1: <Quick mode> The mirror pops back down so that focus can be achieved, and then pops back up to capture the image.

2: <Live mode> The image coming from the sensor is used to set focus.

9 Mirror lockup

This Custom Function turns Mirror lockup on or off. Mirror lockup is used to minimize camera shake during exposures.

0: <Disable> The mirror functions normally.

1: <Enable> The mirror moves up and locks in position with the first push of the shutter button (press

fully). With the second full pressing of the shutter button, the camera takes the picture and the mirror returns to its original position. After 30 seconds, this setting automatically cancels.

C.Fn IV: Auto Operation/Others
10 Shutter button/AE lock button
This controls the functions of the shutter and AE lock buttons. The best way to read this setting is to pay attention to the slash (/) between Shutter button and AE lock button in the description. The shutter button controls the function listed in front of the slash, while the AE lock button ✳ controls the operation listed after it.

0: <AF/AE lock> Autofocus is initiated when the shutter button is depressed halfway / Exposure is locked with ✳ .

1: <AE lock/AF> The shutter button locks exposure when depressed halfway / Autofocus is initiated with ✳ .

2: <AF/AF lock, no AE lock> Exposure is set when the picture is taken / Pressing ✳ temporarily interrupts and locks focus in AI Servo AF mode (continuous focus), preventing focus from being thrown off if an object passes briefly in front of the camera.

3: <AE/AF, no AE lock> Exposure is set the moment the picture is taken / ✳ lets you start and stop AI Servo AF.

11 SET button when shooting
This setting assigns new options to Ⓢᴇᴛ .
0: <Normal> Ⓢᴇᴛ is disabled when shooting.
1: <Change Quality> Ⓢᴇᴛ goes directly to recording quality. (This is useful if you want the ability to quickly change from RAW to JPEG.) The settings appear in the LCD monitor.
2: <Flash exposure comp> Ⓢᴇᴛ takes you to the flash exposure compensation screen. (This is useful if you take a lot of flash pictures.)
3: <LCD monitor On/Off> Ⓢᴇᴛ acts like the DISP. button (some people find this more convenient).
4: <Menu display> Ⓢᴇᴛ acts like the MENU button.

It is up to you to decide whether you find Custom Functions useful. However, they do offer advantages in certain circumstances. For instance, if you shoot after sunset, you can preset the camera to reduce noise during long exposures while making sure the mirror locks up to prevent camera shake.

12 LCD display when power on

This function keeps track of whether the LCD monitor has been turned off to save power.

0: <Display> LCD displays camera settings when the power switch is turned on.

1: <Retain power OFF status> When the power switch is turned on, the LCD display stays off if you have used DISP. to turn off the LCD.

13 Add original decision data

This function is used with the Original Data Security Kit OSK-E3, an optional Canon-designed software package. The software is used to authenticate the image data when used in forensic and other specialized applications. When turned on, the captured image is embedded with verification data.

0: <Off>

1: <On>

Using the LCD Monitor

The LCD monitor is one of the most useful tools available when shooting digital, giving immediate access to your images. You can set your camera so that the image appears for review on the LCD directly after shooting the picture. It's better than a Polaroid print!

The Rebel XSi's 3-inch (76.2 mm) color LCD monitor is much brighter than the monitors of just a couple years ago, but it still takes a little practice to see it well in bright light. You can adjust its brightness level in the Set-up 2 Menu 🔧 (see page 63). Confirm by pressing ⑤ᴇᴛ. However, a bright LCD monitor often makes the image harder to evaluate. The easiest thing to do is to shade the monitor in bright light by using your hand, a hat, or your body to block the sun.

When photographers compare a point-and-shoot digital camera with a larger digital SLR, they often notice that the smaller camera's LCD monitor can be turned on while shooting. Digital point-and-shoot cameras have so-called "live" LCD monitors. Most digital SLRs, however, use a mirror inside the camera (that blocks the path of light from subject to sensor) to direct the image from the lens to the viewfinder. During exposure, the mirror flips up to expose the sensor to light from the image. A live LCD monitor, on the other hand, must be able to see what is coming from the lens at all times in order to feed the LCD monitor. The Rebel XSi marks the first time Canon has included Live View in a Digital Rebel. The Live View mode locks the mirror in the up position and allows you to see what the image sensor sees (see page 148).

LCD Image Review

You can choose to instantly review the image you just shot, and you can also look at all of the previously recorded images stored on your SD card. Most photographers like the immediate feedback of reviewing their images because it allows them to tell if the picture is properly exposed and

Use the LCD to quickly check for proper exposure and sharpness. This image required a short shutter speed to stop the action.
© Haley Pritchard

composed. If not, they can reshoot the scene if that will improve the photo.

It is frustrating to examine a picture and have the instant review function turn off before you are through, so use the XSi's menu system to set the length of time desired to review the images you have just captured. The choices for the duration of review include <2 sec>, <4 sec>, <8 sec>, or <Hold>, all controlled by the <Review time> option in ◘ . You also use this menu selection to activate the <Off> option, which saves power by turning off the LCD monitor, but does not allow you to review the images.

I find that the <2 sec> setting is a bit short and prefer <8 sec>. You can always turn the review off sooner by lightly pressing the shutter button. The <Hold> setting is good if you like to study your photos, because the reviewed image remains on the LCD monitor until you press the shutter but-

ton. But be careful. It is easy to forget to turn off the monitor when you use this selection, in which case your batteries will wear down.

Note: There is a trick not detailed in the camera manual that lets you examine the image as long as you like, even when the duration is not set to <Hold>. As the image appears for review, press 🗑 (for erasing) located on the back of the camera near the right corner. This leaves the image on as long as you want (or at least until the Auto power off time is reached). Obviously you have to be careful not to delete the images, so ignore the <Erase> and <Cancel> options on the bottom of Erase screen. Press the shutter button to quit the image review.

Playback
Reviewing images on the LCD monitor is an important benefit of digital cameras. To see not only your most immediate shot, but also any (or all) of the photos stored on the SD card, press the Playback button ▶ on the back of the camera at the bottom right of the LCD monitor. The last image you captured displays on the LCD monitor. You cycle through the photos by using ◀▶ . If you start by pressing ◀ , you move backward through your images chronologically, starting with the most recent one. If you press ▶ , you'll move forward through the images, beginning with the first image on the card.

Note: Camera buttons with blue-colored labels or icons refer to playback functions.

With the Rebel XSi, you can display the review or playback image in four different formats. Just push DISP. , also found on the back of the camera to the left of the viewfinder, and the different views display progressively. By default, image playback appears in the display mode you last used.

1. **Display with basic information:** The image for review covers the entire LCD screen and includes superimposed data for folder number, image number, shutter speed, aperture, and exposure compensation.

2. **Display with recording quality information:** A similar display to the basic display described above, but image quality information is also shown, along with the number of images that have been recorded on the card.

A great deal of information can be conveyed on the LCD monitor in Playback mode.

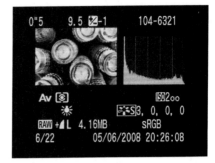

3. **Display with full shooting information:** A thumbnail of the image is shown with a histogram (either Brightness or RGB, depending on how you have set this) and expanded data about how the image was shot (white balance, ISO speed, image recording quality, exposure, and much more). This can be very useful for checking what settings work for you. The thumbnail also includes a Highlight alert function that blinks where areas are overexposed.

4. **Display with histogram:** The histogram display expands to include an RGB histogram. Shooting information is reduced, but includes exposure mode, metering mode, white balance, recording quality, aperture, shutter speed, and file size.

Press the shutter button halfway to stop playback, readying the Rebel XSi to shoot again. You can also stop the playback by pressing ▶ .

Note: When the camera is in Menu mode (any menu displayed on the LCD monitor), you can press **DISP.** to show a status display with a whole host of current camera settings. The screen shows color space, white balance shift and bracketing values, Live View shooting setting, red-eye reduction setting, Auto power off timer setting, Auto rotate setting, LCD auto off, and how much space is available on the memory card in MB.

Automatic image rotation might seem convenient, but the reduction in image size on the LCD makes it difficult to evaluate the image.

Automatic Image Rotation

The Rebel XSi includes an option to automatically rotate vertical images during review or playback. To select this function, go to the 〖Y〗 Menu, highlight <Auto rotate> and press ⑯ . You have three options to choose from: **On** 🖐 🖵, **On** 🖵, and <Off>.

When **On** 🖐 🖵 is enabled and the camera is held in a horizontal position, images appear up-and-down rather than sideways both in the LCD monitor and when you display them on your computer. You can decide for yourself if you like this option, but I really don't use it much. Sure, the image is upright and you don't have to rotate the camera to view it. But the problem is the size of the image. To get that vertical picture to fit in the horizontal frame of the LCD monitor, it has to be reduced considerably and therefore becomes harder to see. I like to use the second option, **On** 🖵. This turns off auto rotate when playing back on the camera, but still lets the computer know that the image should be rotated for display.

Note: You must turn on **On** 🖐 🖵 or **On** 🖵 before you take a picture so that the rotation data gets embedded in the image file.

Magnifying the Image

You can make the image larger on the LCD monitor by factors ranging from 1.5x to 10x. This feature can help you evaluate sharpness and exposure details. When you review

an image, press ⊕ (located on back of the camera in the top right corner) repeatedly to progressively magnify the image. Press ⊞·⊖ (located immediately to the left of ⊕) to reduce the magnification. You can quickly return to full size by pushing ▶ .

Use ✛ to move the magnified image around within the LCD monitor in order to look at different sections of the picture. The Main dial ⌒ moves from one image to another at the same magnified view so you can compare the sharpness of a particular detail, for example.

Note: You do not have to be in the basic information display mode to use the magnify feature. For example, if you are viewing the display with full shooting information, press ⊕ to move all the data off the screen and zoom into the image.

It is a good idea to delete images you are sure you don't want to keep. This saves memory space and makes image review less cluttered.

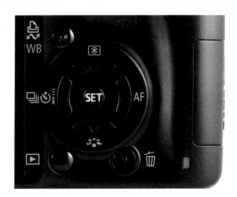

Erasing Images
The Rebel XSi's process for erasing photos from the memory card is the same as that used by most digital cameras: You can erase images during playback or right after exposure when an image appears in review. When an image is displayed on the LCD monitor, push 🗑 . A screen appears with two options: <Cancel>, which exits without deleting an image, and <Erase>, which immediately erases the displayed image. Highlight the appropriate choice and press (set) .

The ▶ Menu also offers a way to delete either all images or more than one image at a time. (See the Note on page 75 for details on using 🗑 for an extended image preview.)

Note: Once an image is erased, it is gone for good. Make sure you no longer want an image before making the decision to erase it.

Image Protection

I consider this feature to be one of a digital camera's most underused and under-appreciated functions. At first, it seems like no big deal—why protect your images? You take care of the memory card and promptly download images to the safety of your computer.

But that's not what image protection is about. Its most important function is to allow you to go through your pictures one at a time on the LCD monitor, choosing which ones to keep, or "protect," meaning all the rest can be discarded.

Protection is easy to apply. Go to ▶ and select <Protect images>. Press ⑤ET and an image displays in the LCD monitor with a key symbol next to the word <SET> at the top left of the photo. Go through your photos one by one using either ◀▶ or the ⚙ . Push ⑤ET for every image that is a potential keeper. A small key icon appears in the information bar at the top of the LCD monitor. Press MENU to exit after protecting the desired image files.

Once you have chosen the protected images, highlight <Erase images> in ▶ , and again press ⑤ET . In the Erase images submenu, highlight <All images on card> and once more press ⑤ET . A screen displays reminding you that you are about to erase all the images on the memory card except those that have been protected. Highlight <OK> and press ⑤ET . All the images on the card are erased except the protected ones. You have now performed a quick edit, giving you fewer photos to download and deal with on the computer.

I knew when I took this shot that it was a "keeper." I made sure to quickly protect it so I didn't accidentally erase it.

Note: There is often downtime when shooting. Use it to select your photos to edit by protecting key shots. However, it is important to realize that protecting images in this way does not safeguard them from the "Format" function. When the camera formats the card, all of the data on the card is erased.

TV Playback

If a group of people needs to see your photos and you have access to a television with a standard RCA video input connection, you can display images from the memory card on the TV.

You may enjoy showing your photos to your friends on a large-screen television. It's easy to do using your Rebel XSi. © Haley Pritchard

First, go to 🍴 and select <Video system>. If you are in North America or Japan, be sure to choose <NTSC>. (In many other parts of the world, you should select <PAL>.) Make sure both the camera and television are turned off, and then connect the camera to the TV using the cables supplied with the camera. Plug into the Video Out connector on the camera and Video In on the television. Turn the TV on, then the camera. Now press ▶ and the image appears on the TV (but not on the back of the camera).

Note: Some TVs cut off the edges of the image.

Image Processing Settings

Canon has long had exceptionally strong in-camera processing capabilities because of their unique DIGIC Imaging Engine (DIGIC for short). The reason the Rebel XSi delivers such exceptional images using JPEG is that Canon's latest version of their high-performance processor, called DIGIC III, builds on the technology from its predecessors.

DIGIC III intelligently translates the image signal as it comes from the sensor, optimizing that signal as it is converted into digital data. In essence, it is like having your own computer expert making the best possible adjustments as the data file is processed for you. DIGIC III works on the image in-camera, after the shutter is clicked and before the image is recorded to the memory card, improving color balance, reducing noise, refining tonalities in the brightest areas, and more. In these ways it has the potential to make JPEG files superior to unprocessed RAW files, reducing the need for RAW processing (see pages 104-111 for more information about JPEG and RAW files).

It is amazing that the DIGIC III can handle data so fast that it does not impede camera speed. The Rebel XSi has a single chip with image data processing that is appreciably faster than earlier units. Color reproduction of highly saturated, bright objects is also considerably improved. Auto white balance is better, especially at low color temperatures (such as tungsten light). In addition, false colors and noise, which have always been a challenge of digital photography, have been reduced (something that RAW files cannot offer). The ability to resolve detail in highlights is also improved.

The DIGIC III chip in the XSi quickly processes image files so they are relatively low in noise. The camera offers many functions to enhance your photos, including Picture Styles, which allow the XSi to create settings to meet the demands of specific shooting situations.

The DIGIC III chip combined with Continuous shooting mode helps capture the action. © Kevin Kopp

DIGIC III also improves the Rebel XSi's ability to write image data to the memory card in both JPEG and RAW, which enables the camera to utilize the benefits offered by high-speed memory cards. It is important to understand that this does not affect how quickly the camera can take pictures. Rather, it affects how fast it can transfer images from its buffer (special temporary memory in the camera) to the card. It won't change the frames per second (fps), but it will improve the quantity of images that can be taken in succession.

There are factors, however, that do affect how many shots per second the camera can take. Having a high-megapixel sensor with its large amount of data has usually meant a slower camera. Yet this is not true of the XSi. It can take pictures at a speedy three fps. Even at maximum resolution, the camera has a burst duration of 53 JPEG or six RAW frames, or four RAW + Large/Fine JPEGs (this occurs only with the fastest memory cards).

During Continuous shooting drive mode, each image is placed into a buffer before it is recorded to the memory card. The faster the memory card is, the faster the buffer is emptied, allowing more images to be taken in sequence. If the buffer becomes full, **buSY** appears in the viewfinder, and the camera stops shooting until the card writing can catch up

The camera is very fast in other mechanical aspects as well: The start-up time is 0.1 seconds—20 times faster than the original Digital Rebel and twice as fast as the XTi; lag time for shutter release is a mere 90 milliseconds (ms); and the viewfinder blackout time (when the mirror is up during shutter speeds of 1/60 and faster) is only 130 ms.

Picture Styles

In addition to the optimizing technology of DIGIC III, you can choose a Picture Style to control how the camera performs some additional image processing. This can be especially helpful if you print image files directly from the camera without using a computer, or when you need to supply a particular type of image to a client. Some photographers compare Picture Styles to choosing a particular film for shooting. Picture Styles are applied permanently to JPEG files. (If using RAW files, the Picture Style can be changed during "processing" using Canon's Digital Photo Professional software.)

You gain access to Picture Styles by pressing the ▼ ♦‡♦ button and using ▲▼ to select the Picture Style you wish to use:

Standard ♦‡S

This is the default style for all the Basic Zone modes (see pages 131-134) except Portrait and Landscape. During in-camera processing, color saturation is enhanced and a moderate amount of sharpening is performed on the image. Standard offers a vivid and crisp image with a normal amount of contrast.

Shooting landscapes is easier when you select the Landscape Picture Style because the camera makes a number of key decisions to optimize colorful, outdoor scenes. © Kevin Kopp

Portrait ᶘᵃᶗP

This is the selected mode for 🐾 in the Basic Zone. It places an emphasis on pleasing skin tones. While the contrast is the same as Standard, skin tones have a slightly warmer look. Sharpening is reduced in order to produce a pleasing soft skin texture.

Landscape ᶘᵃᶗL

This is the selected mode for 🏔 in the Basic Zone. Saturation is high, with an emphasis on blues and greens. There is also a boost in saturation in the yellows. The image is sharpened even more than the Standard mode to display details. Don't be afraid to use this during cloudy days to help bring out more color.

Neutral 𝒫·N

If you plan to "process" the image on your computer either through Canon's Digital Photo Professional software or some other image software program, this may be the mode to choose. There is virtually no image sharpening. Color saturation is lower than other modes and contrast is lower, too. Since other Picture Styles increase saturation, Neutral may be a good mode to choose when you shoot in bright or high-contrast situations. Picture details may be more prevalent with this setting. Don't rule it out for candid portraits that might occur in bright lighting situations.

Faithful 𝒫·F

This is the choice when you need to accurately capture the colors in the scene. Saturation is low and almost no sharpening is applied to the image. Contrast is also toned down. Accurate color reproduction is achieved when the scene is lit with 5200K lighting. Otherwise you might think of this setting as similar to Neutral, except that the color tone is a bit warmer. Like Neutral, this mode is designed with further image processing via computer in mind.

With all of these Picture Styles, you can control the degree of processing applied to four aspects of an image:

- **<Sharpness>** Refers to the amount of sharpening that is applied to the image file by the camera.

- **<Contrast>** Increases or decreases the contrast of the scene that is captured by the camera.

- **<Saturation>** Influences color richness or intensity.

- **<Color tone>** Helps the photographer decide how red or how yellow to render skin tones, but also affects other colors.

Remember that the color is gone forever if you shoot JPEGs in Monochrome Picture Style. But if you set the image quality to RAW + JPEG while shooting in Monochrome, you can record a black and white picture and still retain color information with the RAW file.
© Kevin Kopp

Monochrome ᠌᠌᠌᠌M

This Picture Style allows you to record pure black-and-white images to the memory card and to automatically view the image in black-and-white on the LCD. Sharpness is the same as the Standard mode and contrast is enhanced. As with the other Picture Styles, Monochrome changes JPEG files permanently—you can't get the color back. Another option is to shoot in color and convert images to black and white in an image-processing program—and do so with more control.

For Monochrome (black-and-white), the parameters are different than for the other Picture Styles. They are <Sharpness>, <Contrast>, <Filter effect>, and <Toning effect>.

Use ⌂⁖ to modify Picture Styles. Highlight <Picture Style> and then press (SET) . A list of all the Picture Styles is presented, along with a series of numbers representing the current parameter settings for each style. Parameter numbers displayed in blue indicate a setting that has been changed from the default setting.

Note: While the ▼ ⁖ key is the fastest way to select a Picture Style, you can also use this screen to select one. Just highlight the style you wish to use and press (SET) . The Picture Style currently in use is in blue.

Scroll to highlight the picture style you wish to change. Press **DISP.** to enter the Detail set. submenu. (To return to the Shooting Menu screen at any time, press **MENU**.)

The Detail set. submenu allows you to further adjust the styles. <Sharpness>, <Contrast>, <Saturation>, and <Color tone> are represented by a selection point on a slider-type scale. With the exception of Sharpness, the default setting is 0 (no user changes).

Each Picture Style parameter is flexible. Use ▲▼ to select the parameter that you want to adjust. Press (SET) to enter adjustment mode. A white pointer shows the current setting. The gray pointer shows the default setting for that style. Use ◄► to adjust the parameter. You must use (SET) to accept the setting. If you leave this menu screen without pressing (SET) , the adjustment is cancelled. There is also a <Default set> option at the bottom of the screen accessed by ▲▼ . Use this to reset the Picture Style to its factory setting. Use **MENU** to return to the Picture Style Menu.

The adjustment slider for Sharpness is set up differently than the other sliders. Sharpness is generally required at some point in digital photography to overcome, among other things, the use of a low-pass filter in front of the image sensor to reduce problems caused by the grid of pixels on the image sensor. The low-pass filter introduces a small amount of image blur and image sharpening compensates for this

blur. The adjustment slider's setting indicates the amount of sharpness already applied to the style. A setting of zero means that almost no sharpening has been applied to the image. You'll notice that the Sharpness parameter's default setting is the only one that changes from Picture Style to Picture Style.

With the Monochrome Picture Style, the Saturation and Color tone settings are replaced with <Filter effect> and <Toning effect>. The parameters for Filter effects offer four tonal effects that mimic what a variety of colored filters do to black-and-white film (see below). A fifth setting, <N:None>, means that no filter effects are applied. Each Filter effect color choice makes the color similar to your selection look lighter, while the color opposite your selection on the color wheel records darker. The Monochrome Filter effects are:

- <**Ye:Yellow**> is a modest effect that darkens skies slightly and gives what many black-and-white aficionados consider the most natural looking grayscale image.

- <**Or:Orange**> is next in intensity. It does what red does, only to a lesser degree. So it is better explained if you understand the use of red (see next description).

- <**R:Red**> is dramatic, lightening anything that is red, such as flowers or ruddy skin tones, while darkening blues and greens. Skies turn quite striking and sunlit scenes gain in contrast (the sunny areas are warm-toned and the shadows are cool-toned, so the warms get lighter and the cools get darker).

- <**G:Green**> makes Caucasian skin tones look more natural and foliage gets bright and lively in tone.

Of course, the great thing about shooting with the Rebel XSi is that if you aren't sure what these filters will do, you can take the picture and see the effect immediately on the LCD monitor.

The User-defined Picture Styles give you the opportunity to create a group of settings to handle specialized situations, such as a foggy morning in the country.

The other Monochrome parameter, Toning effect, adds color to the black-and-white image so it looks like a toned black-and-white print. Your choices include: <N:None>, <S:Sepia>, <B:Blue>, <P:Purple>, and <G:Green>. Sepia and blue are the tones we are most accustomed to seeing in such prints.

User-Defined Picture Styles

The XSi allows you to utilize a particular Picture Style as a base setting and modify it to meet your own photographic needs. This allows you to create and register a different set of parameters you can apply to image files while keeping the preset Picture Styles. You do this under the options for <User Def. 1>, <User Def. 2>, or <User Def. 3>.

While specific situations may affect where you place your control points for these flexible options, here are some suggestions to consider:

- Create a hazy or cloudy day setting: Make one of the user-defined sets capture more contrast and color on days when contrast and color are weak. Increase the scale for Contrast and Saturation by one or two points (experiment to see what you like when you open the files on your computer or use the camera for direct printing). You can also increase the red setting of Color tone (adjust the scale to the left).

- Create a portrait setting: Make a set that favors skin tones. Start with the Portrait style as your base, then reduce Contrast by one point while increasing Saturation by one point (this is very subjective—some photographers may prefer less saturation) and warming skin tones (by moving Color tone toward the red—or left—side) by one point.

- Create a Velvia (an intensely colored slide film) look: Start with Standard style, increase Contrast two points, Sharpness one point, and Saturation by two points.

You can also download custom Picture Styles from Canon's Picture Style website:

http://web.canon.jp/imaging/picturestyle/index.html

These custom styles can be uploaded into any of the XSi's three User-defined fields by using the USB connection to the camera. (Requires Canon's EOS Utility software that is included with the camera.) The custom styles can also be used with Canon's Digital Photo Professional to change styles after-the-fact in RAW images.

Note: Downloaded Picture Styles can only be loaded into the User-defined styles and are deleted if you reset all camera settings using <Clear settings> in 🔧 .

Color Space

The XSi has a color space setting in the ◯: menu. Color space is the range of colors or gamut that a device can produce. Cameras have color spaces, monitors have color spaces, and printers have color spaces. (While not technically accurate, you can think of different color spaces as different sized boxes of crayons.)

The two choices for color space on the XSi are sRGB and Adobe RGB. sRGB is the default setting for the camera and is used as the color space for the Basic shooting zones. It is also the color space for most computer monitors. If you are capturing images for the web, sRGB will work fine. Adobe RGB, as the name implies, was developed by Adobe to deal with printers. This larger color space (think bigger box of crayons) contains most of the colors that can be produced by today's printers.

Choosing between sRGB and Adobe RGB is not as complicated as JPEG vs. RAW. The Adobe RGB doesn't take up more room on the card or require special RAW processing software. But you do need to check to make sure that your image-processing program can handle Adobe RGB—most do.

There are many times when it is difficult to see the difference between the two color spaces. Try an experiment with some test shots in both. You won't see the difference on the LCD, so print them out and then see if you can tell the difference.

White Balance

White balance (WB) is an important digital camera control. It addresses a problem that has plagued film photographers for ages: How to deal with the different color temperatures of various light sources. While color adjustments can be made in the computer after shooting, especially when shooting RAW, there is a definite benefit to setting white balance

Automatic white balance generally gives good results, but white balance presets are also good choices. In situations like this one—a green frog sitting on green foliage—AWB may not interpret the situation correctly, resulting in color casts.

properly from the start. The Rebel XSi helps you do this with an improved Auto white balance **AWB** setting that makes colors more accurate and natural than earlier digital SLRs. In addition, improved algorithms and the DIGIC III processor make **AWB** more stable as you shoot a scene from different angles and focal lengths (which is always a challenge when using this setting). Further, white balance has been improved to make color reproduction more accurate under low lights.

While **AWB** gives excellent results in a number of situations, many photographers find they prefer the control offered by presets and custom WB settings. With eight separate white balance settings, plus white balance compensa-

tion and bracketing, the Rebel XSi's ability to carefully control color balance is greatly enhanced. It is well worth the effort to learn how to use the different white balance functions so you can get the best color with the most efficient workflow in all situations (including RAW). This is especially important in strongly colored scenes, such as sunrise or sunset, which can fool ⬛AWB.

White Balance Presets
The preset WB settings are simple enough to learn that they should become part of the photography decision-making process. However, they can only be used with the Creative Zone exposure modes (see pages 134-143). The more involved Custom white balance setting ⬛ is also a valuable tool to understand and use so you can capture the truest color in all conditions (see pages 98-100).

To set white balance when there are no menus displayed on the LCD, press the **WB** button found on the back of the camera to the right of the LCD. A list of WB choices appears. Next, use ◀▶ and (SET) to choose the white balance setting you want. The information display on the LCD monitor shows an icon of the white balance setting that you selected.

White balance settings fall within certain color temperature values, corresponding to a measurement of how cool (blue) or warm (red) the light source in the scene is. The measurement is in degrees Kelvin, abbreviated as K. The higher the number, the cooler the light source. Conversely the lower the number, the warmer the light source. These settings and their corresponding Kelvin temperature are:

Auto ⬛AWB **(Color temperature range of approximately 3000–7000K):** This setting examines the scene for you, interprets the light it sees (in the range denoted above) using the DIGIC III processor (even with RAW), compares the conditions to what Canon's engineers have determined works for such readings, and sets a white balance to make colors look neutral (i.e., whites appear pure, without color casts, and skin tones appear normal).

Auto can be a useful setting when you move quickly from one type of light to another, or whenever you hope to get neutral colors and need to shoot fast. Even if it isn't the perfect setting for all conditions, it often gets you close enough so that only a little adjustment is needed later using your image-processing software. However, if you have time, it is often better to choose from the white balance settings listed below, because colors are more consistent from picture to picture. While Auto is well designed, it can only interpret how it "thinks" a scene should look. If the camera sees your wide-angle and telephoto shots of the same subject differently in terms of colors, it will readjust for each shot, often resulting in inconsistent color from shot to shot.

Daylight ☀ **(approximately 5200K):** This setting adjusts the camera to make colors appear natural when you shoot in sunlit situations between about 10 A.M. and 4 P.M. (middle of the day). At other times, when the sun is lower in the sky and has more red light, the scenes photographed using this setting appear warmer than normally seen with our eyes. This setting makes indoor scenes under incandescent lights look very warm, indeed.

Shade 🏠 **(approximately 7000K):** Shadowed subjects under blue skies can end up very bluish in tone, so this setting warms the light to make colors look natural, without any blue colorcast. (At least that's the ideal—individual situations affect how the setting performs.) The Shade setting is a good one to use any time you want to warm up a scene (especially when people are included), but you have to experiment to see how you like this creative use of the setting.

Cloudy ☁ **(approximately 6000K):** Even though the symbol for this setting is a cloud, you might think of it as the Cloudy/twilight/sunset setting. It warms up cloudy scenes as if you had a warming filter, making sunlight appear warm, but not quite to the degree that the Shade setting does. You may prefer the Cloudy setting to Shade when shooting people, since the effect is not as strong. Both settings actually work well for sunrise and sunset, giving the warm colors that

In difficult situations where you aren't sure of the color temperature, make your best guess to select a white balance preset and shoot RAW. Setting a preset instead of AWB will save time when you go to process the RAW files.

we expect to see in such photographs. However, the Cloudy setting offers a slightly weaker effect. You really have to experiment a bit when using these settings for creative effect. Make the final comparisons on the computer.

Tungsten Light ☀ **(approximately 3200K):** Tungsten light is designed to give natural results with quartz lights. It also reduces the strong orange color that is typical when photographing lamp-lit indoor scenes with daylight-balanced settings. Since this control adds a cold tone to other conditions, it can also be used creatively for this purpose (to make a snow scene appear bluer, for example).

White Fluorescent Light ☲ **(approximately 4000K):** The AWB setting often works well with fluorescents but, under many conditions, the White fluorescent light setting is more precise and predictable. Fluorescent lights usually appear

green in photographs, so this setting adds magenta to neutralize that effect. (Since fluorescents can be extremely variable, and since the Rebel XSi has only one fluorescent choice, you may find that precise color can only be achieved with the Custom white balance setting.) You can also use this setting creatively any time you wish to add a warm pinkish tone to your photo (such as during sunrise or sunset).

Flash ⚡ (approximately 6000K): Light from flash tends to be a little colder than daylight, so this warms it up. According to Canon tech folks, this setting is essentially the same as Cloudy (the Kelvin temperature is the same); it is simply labeled differently to make it easy to remember and use. I actually use both Flash and Cloudy a lot, finding them to be good, all-around settings that give a slight but attractive warm tone to outdoor scenes.

Custom White Balance 🔳

A very important tool for the digital photographer, Custom white balance is a setting that even pros often don't fully understand. It is a precise and adaptable way of getting accurate or creative white balance. It has no specific white balance K temperature, but is set based on a specific neutral tone in the light in the scene to be photographed. However, it deals with a significantly wider range than Auto (between approximately 2000–10,000K). That can be very useful.

The Custom setting lets you choose a white (or gray) target on which the camera sets white balance. First, take a picture of something white (or a known neutral tone) that is in the same light as your subject. You can use a piece of paper or a gray card. It does not have to be in focus, but it should fill the image area. (Avoid placing the card on or near a highly reflective colored surface.) Be sure the exposure is set to make this object gray to light gray in tone, and not dark (underexposed) or washed out white (overexposed).

Tip: I like to use a card or paper with black print on it rather than a plain white card. This way, if I can see the type, I haven't overexposed the image.

Custom white balance is an underutilized setting in most D-SLRs. The XSi includes this option that is great for scenes where the lighting comes from two or more sources, such as this sanctuary with sunlight coming through colored glass and fluorescent lighting overhead. © Kevin Kopp

Next, go to ◘⁚ and highlight <Custom WB>, then press ⑤ᴇᴛ . The last shot you took (the one for white balance) should be displayed in the LCD monitor. If not, use ◀▶ to choose the image you shot of the white or gray object.

When you have the target image displayed in the LCD monitor, push ⑤ᴇᴛ . A dialog box asks you if you want to use the white balance information from the current image to set a custom white balance. Highlight <OK>, press ⑤ᴇᴛ , and the Custom white balance is set to measure that stored shot. A note appears, "Change WB to Custom WB," as a reminder. This reminds you that there is one more step to this process: You must choose the ⊾⊿ setting for white balance.

To take that final step, press (SET) again to acknowledge the reminder, and then either lightly tap the shutter or press **MENU** to exit the Custom WB menu. Then press the **WB** button and select 🔲 . Of course, don't forget to lock in the selection with (SET) . The camera is now set for your Custom white balance.

You may save a series of white balance reference images on your memory card ahead of time that you can flip through. This is useful if you need to switch between different lighting conditions but don't have the time to set up a card to capture the image.

The procedure just described produces neutral colors in some very difficult conditions. However, if the color of the lighting is mixed, like a situation where the subject is lit on one side by a window and on the other by incandescent lights, you will only get neutral colors for the light that the white card was in. Also, when shooting in reduced spectrum lights, such as sodium vapor, you will not get a neutral white under any white balance setting.

You can also use Custom white balance to create special color for a scene. In this case, you white balance on a color that is not white or gray. You can use a pale blue, for example, to generate a nice amber color. If you balance on the blue, the camera adjusts this color to neutral, which in essence removes blue, so the scene has an amber cast. Different strengths of blue provide varied results. You can use any color you want for white balancing—the camera works to remove (or reduce) that color, which means the opposite color becomes stronger. (For example, using a pale magenta increases the green response.)

White Balance Correction

The Rebel XSi goes beyond the capabilities of many cameras in offering control over white balance: There is actually a white balance correction feature built into the camera. You might think of this as exposure compensation (see page 145) for white balance. It is like having a set of color balancing

Sometimes the white balance presets only get you close to the proper white balance. With the XSi, you can use the in-camera white balance correction function to refine the image and get the exact results you want.

filters in four colors (blue, amber, green, and magenta) and in varied strengths. Photographers accustomed to using color conversion or color correction filters will find this feature quite helpful in getting just the right color.

The setting is not difficult to manage. First, go to ◘**ⁱ** , highlight <WB SHIFT/BKT> and press ⑤ᴇᴛ . A menu screen appears with a graph that has a horizontal axis from blue to amber (left to right) and a vertical axis from green to magenta (top to bottom). You move a selection point within that graph using the cross keys. As you change the position of the selection point on the graph, an alphanumeric display titled <SHIFT> on the right of the screen shows a letter for the color (B, A, G, or M) and a number for the setting. For example, a white balance shift of three steps toward blue and four to green displays B3 and G4.

For photographers used to color-balancing filters, each increment of color adjustment equals 5 MIREDS of a color-temperature changing filter. (A MIRED is a measuring unit for the strength of a color temperature conversion filter.) Remember to set the correction back to zero when conditions change. The LCD monitor and the viewfinder information display show 🔲 when white-balance correction is engaged.

White Balance Auto Bracketing
When you run into a difficult lighting situation and want to be sure of the best possible white balance settings, another option is white balance auto bracketing. This is actually quite different than autoexposure bracketing (see page 146). With the latter, three separate exposures are taken of a scene; with white balance auto bracketing, you take just one exposure and the camera processes it to give you three different white balance options.

Note: Using white balance bracketing delays the recording of images to the memory card. In other words, the burst mode of the camera is reduced and the number of shots in a row is one-third the normal number. Pay attention to the access lamp on back of the XSi in the bottom right corner to gauge when the camera is finished recording the extra images.

White balance auto bracketing allows up to +/- 3 levels (again, each step is equal to 5 MIREDS of a color correction filter) and is based on whatever white balance mode you have currently selected. You can bracket from blue to amber or from green to magenta. Keep in mind that even at the strongest settings, the color changes are fairly subtle. 🔲
on the LCD monitor appears to let you know that white balance auto bracketing is set.

To access white balance auto bracketing, go to 🔲 and select <WB SHIFT/BKT>, then press ⓢ . The graph screen with the horizontal (blue/amber) and vertical (green/magenta) axes appears on the LCD monitor. Rotate 🔄 to adjust the bracketing amount: To the right (clockwise) to set the blue/amber adjustment, then back to zero and go to the

left (counter clockwise) for green/magenta. (You can't bracket in both directions.) You can also shift your setting from the center point of the graph by using ✧ . Press ⑤ to accept your settings.

Note: The default for white balance bracketing records an original image at the currently selected white balance setting, then internally creates an additional set of (1) a bluer image and a more amber image, or (2) a more magenta and a greener image. Remember, unlike exposure bracketing, you only need to take one shot—you do not have to set the drive setting to ▣ .

The obvious use of this feature is to deal with tricky lighting conditions. However, it has other uses as well. You may want to add a warm touch to a portrait but are not sure how strong you want it. You could set the white balance to ☁ , for example, then use white balance auto bracketing to get the tone you're looking for. (The bracketing gives you the standard ☁ white-balanced shot, plus versions warmer and cooler than that.) Or, you may run into a situation where the light changes from one part of the image to another. Here, you can shoot the bracket, then combine the white balance versions using an image-processing program. (Take the nicely white-balanced parts of one bracketed photograph and combine them with a different bracketed shot that has good white balance in the areas that were lacking in the first photo.)

White Balance and RAW
Since the RAW file format (see following pages) allows you to change white balance after the shot, some photographers have come to believe that it is not important to select an appropriate white balance at the time the photo is taken. While it is true that ▣ and RAW give excellent results in many situations, this approach can cause consistency and workflow challenges. White balance choice is important because when you bring CR2 files (the XSi's RAW format) into software for processing and enhancement, the files open with the settings that you chose during initial image capture.

Sure, you can edit those settings in the computer, but why not make a good RAW image better by merely tweaking the white balance with minor revisions at the image-processing stage rather than starting with an image that requires major correction? Of course there will be times that getting a good white balance setting is difficult, and this is when the RAW software white balance correction can really be a big help.

File Formats

The Rebel XSi records images as either JPEG or RAW files. There has been a mistaken notion that JPEG is a file format for amateur photographers while RAW is a format for professionals. This is really not the case. Pros use JPEG and some amateurs use RAW. (Technically, JPEG is a compression scheme and not a format, but the term is commonly used to denote format and that is how we will use it.)

There is no question that RAW offers some distinct benefits for the photographer who needs them, including the ability to make greater changes to the image file before the image degrades from over-processing. RAW is not a standard file format like JPEG, and camera manufacturers each have a proprietary version of RAW that they offer in their cameras. The Rebel XSi's RAW format (CR2) was originally developed by Canon for the EOS-1D Mark II. It includes revised processing improvements, making it more flexible and versatile for photographers than previous versions. It can also handle more metadata and is able to store processing parameters for future use.

However, RAW is not for everyone. It requires more work and more time to process than other formats. For the photographer who likes to work quickly and wants to spend less time at the computer, JPEG may offer clear advantages and, with the Rebel XSi, even give better results. This might sound radical considering what some "experts" say about RAW in relation to JPEG, but I suspect they have never shot an image with an EOS Rebel XSi set for high-quality JPEGs.

Some think RAW is for professionals and JPEG is for amateurs. That is not necessarily so. Pros often shoot JPEG and submit them for publication. © Haley Pritchard

It is important to understand how the sensor processes an image. It sees a certain range of tones coming to it from the lens. Too much light (overexposed), and the detail washes out; too little light (underexposed), and the picture is dark. This is analog (continuous) information, and it must be converted to digital, which is true for any file format, including both RAW and JPEG. The complete digital data is based on 14 bits of color information, which is changed to 8-bit color data for JPEG, or simply placed virtually unchanged into a 16-bit file for RAW. (The fact that RAW files contain 14-bit color information is a little confusing since this information is put into a file that is actually a 16-bit format.) This occurs for each of three different color channels used by the Rebel XSi: red, green, and blue. Remember that the DIGIC III processor applies changes to JPEG files, while RAW files have very little processing applied by the camera.

Note: A bit is the smallest piece of information that a computer uses—an acronym for binary digit. Data of eight bits or higher are required for true photographic color.

Both 8-bit and 16-bit files have the same range from pure white to pure black because that range is influenced only by the capability of the sensor. If the sensor cannot capture detail in areas that are too bright or too dark, then a RAW file cannot deliver that detail any better than a JPEG file. It is true that RAW allows greater technical control over an image than JPEG, primarily because it starts with more data (14 bits in a 16-bit file), meaning there are more "steps" of information between the white and black extremes of the sensor's sensitivity range. These steps are especially evident in the darkest and lightest areas of the photo. So it appears the RAW file has more exposure latitude and that greater adjustment to the image is possible before banding or color tearing becomes noticeable.

JPEG format compresses (or reduces) the size of the image file, allowing more pictures to fit on a memory card. The JPEG algorithms carefully look for redundant data in the file (such as a large area of a single color) and remove it, while keeping instructions on how to reconstruct the file. JPEG is therefore referred to as a lossy format because, technically, data is lost. The computer rebuilds the lost data quite well as long as the amount of compression is low.

It is essential to note that both RAW and JPEG files can give excellent results. Photographers who shoot both use the flexibility of RAW files to deal with tough exposure situations, and JPEG files when they need fast and easy handling of images.

Which format will work best for you? Your own personal way of shooting and working should dictate that. If you deal with problem lighting and colors, for example, RAW gives you a lot of flexibility in controlling both. If you can carefully control your exposures and keep images consistent, JPEG is more efficient.

RAW files, such as Canon's CR2 format, help you deal with bright or lowlight situations by allowing you to recover details in both highlight and shadow areas of your photos. You can also achieve excellent results with less time on the computer by shooting JPEGs.

Processing RAW Files

In addition to the fact that it holds 14 bits of data, the RAW file also offers advantages because it more directly captures what the sensor sees and can have stronger correction applied to it (compared to JPEG images) without problems appearing. This can be particularly helpful when there are difficulties with exposure or color balance.

The disadvantage to RAW files is that you must process the image using RAW processing software on your computer. A RAW file needs to be processed: You can't print a RAW file and you can't post it for viewing on a website. Canon supplies RAW processing software with the Rebel XSi (see page 207). Additional RAW processing programs are also available from independent third-party developers. One disadvantage to using third-party programs for converting CR2

files is that they may not support Canon's Dust Delete Data system (see page 54) to automatically remove dust artifacts in your images. Also, Picture Styles may not be supported in software other than Canon's.

Whatever method you choose to gain access to RAW files in your computer, you have excellent control over the images in terms of exposure and color of light. The RAW file contains special metadata (shooting information stored by the camera) that has the exposure settings you selected at the time of shooting. This is used by the RAW conversion program when it opens an image. You can make modifications to the exposure without causing too much harm to the file. (Though you can't compensate for really bad exposure in the first place.) White balance settings can also be changed. If you use Canon's software, you can even change Picture Styles after the fact.

Image Size and Quality

The Rebel XSi offers a total of 8 choices for image-recording quality, consisting of combinations of different file formats, resolutions (number of pixels), and compression rates. But let's be straight about this: Most photographers will shoot the maximum image size using RAW or the highest-quality JPEG setting. There is little point in shooting smaller image sizes except for specialized purposes. After all, the camera's high resolution is what you paid for!

All settings for recording quality are selected in the ◘˙ menu under <Quality>. Press ⑤ to make the different quality options appear, designated by a symbol and a letter. The symbols depict the level of compression; the letter stands for the resolution size of the image file.

The symbol with the smooth curve represents the lesser amount of compression (Fine = better quality), and when combined with L (large resolution size), makes a very high quality image. The symbol with a stair shape illustrates higher compression (Normal = lesser quality), giving a good quality JPEG image, but not as good as the Fine setting. The

If you want prints of your pictures, it is best to set the image-recording quality to RAW or to the highest quality JPEG at the maximum pixel size. The highest resolution usually renders more detail and always give you the option to make bigger prints.

most important settings are ◢L (the largest image size for JPEG, 12.2 megapixels) and RAW (which is always 12.2 megapixels—since it is uncompressed, no compression symbol is displayed).

Note: Near the top of the Quality Menu is a status line that shows the current selection, the size of the image file in megapixels, the dimensions of the image file in pixels, and the number of images at the current image-recording quality that will fit in the space that is currently available on the memory card.

The Rebel XSi can record both RAW and JPEG simultane-ously. Designated **RAW**+◢**L**, this option can be useful for photographers who want added flexibility. It records images using the same name prefix, but with different formats desig-nated by their extensions: .JPG for JPEG and .CR2 for RAW. You can then use the JPEG file, for example, for direct print-ing, quick usage, and to take advantage of the DIGIC III processor. And you still have the RAW file for use when you need its added processing power. (**RAW**+◢**L** setting cannot be used in the Basic zone).

If you find yourself frequently switching between quality settings, you can set Custom Function (C.Fn) 11 (see page 71) to increase the functionality of (SET) . When this function is utilized, you won't have to press **MENU** to call up the Quality Menu and then navigate to <Quality>. You simply press (SET) and the Quality Menu appears on the LCD monitor. Then it is just a matter of selecting the desired item by pressing (SET) and you can start shooting at the new setting.

Note: If you enable Live View shooting, custom function programming of (SET) is overridden.

The RAW file first appears in your RAW conversion software with the same processing details as the JPEG file (including white balance, color matrix, and exposure), all of which can be altered in the RAW software. Though RAW is adaptable, it is not magic. You are still limited by the original exposure, as well as by the tonal and color capabilities of the sensor. Using RAW is not an excuse to become sloppy in your shooting simply because it gives you more options to control the look of your images. If you do not capture the best possible file, your results will be less than the camera is capable of producing.

Each recording quality choice influences how many photos can fit on a memory card. Most photographers shoot with large memory cards because they want the space required by the high-quality files available on this camera. It is impossible to give exact numbers of how many JPEG images fit on a card because this compression technology is variable. You can

change the compression as needed (resulting in varied file sizes), but remember that JPEG compresses each file differently depending on what is in the photo and how it can be compressed. For example, a photo with a lot of detail does not compress as much as an image with a large area of solid color.

That said, the chart below gives you an idea of how large these files are and how many images might fit on a two gigabyte (GB) memory card. The figures are based on actual numbers produced by the camera using such a card. (JPEG values are always approximate.) Also, the camera uses some space on the card for its own purposes and for file management, so you do not have access to the entire two GB capacity for image files.

You can immediately see one advantage that JPEG gives over RAW in how a memory card is used. The highest-quality JPEG file at the full 12.2 megapixels allows you to store nearly four times the number of photos compared to what you can store when you shoot RAW.

Image Size and Card Capacity Based on 2GB Memory Card

Quality	Megapixels	File Size (Approx MB)	Possible Shots	Max Burst
▲L (High)	Approx 12.2	4.3	460	53
�ﬂL (High)	Approx 12.2	2.2	880	880
RAW (High)	Approx 12.2	15.3	120	6
RAW + ▲L (High)	Approx 12.2	15.3 + 4.3	99	4
▲M (Medium)	Approx 6.3	2.5	770	770
ﬂM (Medium)	Approx 6.3	1.3	1470	1470
▲S (Small)	Approx 3.4	1.6	1190	1190
ﬂS (Small)	Approx 3.4	0.8	2290	2290

All quantities are approximate based on the photographic subject, brand and type of memory card, ISO speed, and other possible factors.

Shooting Operations

Clearly the Rebel XSi is a highly sophisticated camera. The innovation, thought, and technology that have gone into the XSi become evident as soon as you begin to operate its various systems and utilize its many functions. From finding focus on moving subjects, to shooting multiple frames per second, to capturing great exposures in low light, the Rebel XSi offers a number of options that enhance your ability to take excellent photographs.

Focus

The Rebel XSi uses an AI Focus AF (artificial intelligence autofocus) system based on a special CMOS sensor dedicated to autofocus. The nine AF points give the camera nine distinct spots where it can measure focus. They are arranged in a diamond pattern. The diagonal arrangement of autofocus points around the center makes for improved focus tracking of moving subjects.

The AF points work with an EV (exposure value) range of EV –0.5 to +18 (at ISO 100), and are superimposed in the viewfinder. They can be used automatically (the camera selects them as needed), or you can choose one manually.

The Rebel XSi smartly handles various functions of autofocus through the use of a high-performance, 32-bit RISC microcomputer along with improvements in AF system design. The camera's ability to autofocus while tracking a moving subject is quite good. According to Canon, for example, in AI Servo AF (continuous focus) with an EF 300mm f/2.8 IS USM lens, the Rebel XSi can focus-track a subject moving toward the

The XSi provides a wide selection of exposure settings, shutter speeds, and in-camera processing options, as well as remote capability, offering you the opportunity to be creative in your photography.

Manually selecting focus points brings total control to the XSi auto-focus system.

camera at a speed of 31 mph (50 kph) up to about 32.8 feet (10 meters) away. And this specification doesn't just mean that the XSi can track only objects moving 31mph and slower. For example AI Servo AF can track a race car traveling at 124 mph (200 kph) until it is about 65.6 feet (20m) from the camera. The XSi does this by employing statistical prediction while using multiple focusing operations to follow even an erratically moving subject. And yet, if the subject is not moving, the AI Servo AF control is notably stable—it will not allow the lens to change focus until the subject moves again.

When light levels are low, the camera activates AF-assist with the built-in flash and produces a series of quick flashes to help autofocus. (External dedicated flashes can also do this—see Custom Function (C.Fn) 7 on page 70.) The range is up to approximately 13.1 feet (4 meters) in the center of the frame and 11.5 feet (3.5 meters) at the other AF points. The 580EX II Speedlite includes a more powerful AF-assist beam effective up to 32.8 feet (10 meters).

One-Shot AF is great when you've asked your subjects to stand still, and of course for landscapes and still lifes. You can lock focus on a point in the scene and recompose while holding the shutter down halfway. © Kevin Kopp

AF Modes

The camera has three AF modes: One-Shot AF, AI Servo AF, and AI Focus AF. Manual focusing is also an option. In the Basic Zone modes, the AF mode is set automatically. In the Creative Zone modes, you can choose among all three settings. They are accessed by pressing ▶ **AF** (right cross key), causing the AF Mode Menu to display on the LCD monitor. Use ◀▶ to select the mode you want. Once selected, press ⓢᴇᵀ to accept the selection. The selected AF mode is indicated on the camera settings display on the LCD monitor.

Each AF mode is used for different purposes:

One-Shot ONE SHOT: This AF mode finds and locks focus when you press the shutter button halfway. Perfect for stationary subjects, it allows you to find and hold focus at the important part of a subject. If the camera doesn't hit the right spot, simply change the framing slightly and repress the shutter button halfway to lock focus. Once you have found focus and locked, you can then move the camera to set the proper composition. The focus confirmation light glows steadily in the viewfinder when you have locked focus. It blinks when the camera can't achieve focus. Since this camera focuses very quickly, a blinking light is a quick reminder that you need to change something (you may need to focus manually).

AI Servo AI SERVO: Great for action photography where subjects are in motion, AI Servo AF becomes active when you press the shutter button halfway, but it does not lock focus. It continually looks for the best focus as you move the camera or as the subject travels through the frame, with both the focus and exposure becoming set only at the moment of exposure. This can be a problem when used for motionless subjects because the focus continually changes, especially if you are handholding the camera. However, if you use AI Servo AF on a moving subject, it is a good idea to start the camera focusing (depressing the shutter halfway) before you actually need to take the shot so the system can find the subject.

AI Focus AI FOCUS: This mode allows the camera to choose between **ONE SHOT** and **AI SERVO**. It can be used as the standard setting for the camera because it switches automatically from **ONE SHOT** to **AI SERVO** if your subject should start to move. Note, however, that if the subject is still (like a landscape), this mode might detect other movement (such as a blowing tree), so it may not lock on the non-moving subject.

AI Servo AF gives you confidence that quickly moving action will stay in sharp focus. © Kevin Kopp

Selecting an AF Point

You can let the camera select the AF point automatically, or you can manually select a desired point. Manual AF point selection is useful when you have a specific composition in mind and the camera won't focus consistently where you want. To manually select an AF point, simply push the ⊞ button (on back of the camera in the upper right corner, it is also ⊕ during playback), and use ✛ or ⊰ to make your selection. Points light up in the viewfinder and on the LCD monitor as they are selected. If all points are lit, the camera automatically makes the AF point selection. You can press (SET) to jump directly to the center AF point. Once there you can use (SET) to toggle between the center AF point and automatic selection. This is an intuitive control that is simple to use.

Using 🔆 rotates through all of the points and is not as direct as selecting points with ✛ . However, some photographers find the dial is easier to use while looking through the viewfinder.

You can return to shooting mode at any time during AF point selection by either pressing the shutter half way or pressing ⊞ . You do not need to press ⓢ to have the camera accept your selection.

Autofocus Limitations

AF sensitivity is high with this camera. The Rebel XSi can autofocus in conditions that are quite challenging for other cameras. Still, as the maximum aperture of lenses decreases, or tele-extenders are used, the camera's AF capabilities change. AF works best with f/2.8 and wider lenses. This is normal and not a problem with the camera.

It is possible for AF to fail in certain situations, requiring you to focus manually. This is most common when the scene is low contrast or has a continuous tone (such as sky), in conditions of extreme low light, with subjects that are strongly backlit, and with compositions that contain repetitive patterns. A quick way to deal with these situations is to focus on something else at the same distance, lock focus on it (by keeping the shutter pressed halfway), then move the framing back to the original composition. This only works while the camera is in **ONE SHOT** mode.

Manual focus is activated by setting the Lens Focus Mode switch, located on your lens, to **MF** . Turn the focus ring on the lens to adjust focus.

An object between you and your subject, like the bars in this fence, could fool the camera's autofocus. Focusing manually can help insure the subject is captured sharply in such situations.

Drive Modes and the Self-Timer

The term drive comes from film cameras where professional SLRs had an option to advance the film and reset the shutter with a motor drive. Even though the film is gone, mechanics are still needed in any digital SLR. The Rebel XSi offers several different drive modes accessed when you press ◄⌷/ঔ: (left cross key). The Drive Mode Menu displays on the LCD monitor. Use ◄► to highlight the drive mode you want from the menu options, and press ⑤ to accept the selection. Any drive mode that you select is indicated on the camera settings display on the LCD monitor.

Single Shooting ☐
This is the standard shooting mode. One image is captured each time you press the shutter release.

119

Continuous Shooting ⏱

When the shutter button is held down, the camera captures at a rate of 3.5 images per second for 53 consecutive JPEG images at the highest JPEG resolution and best quality. When the in-camera buffer fills up, the camera stops capturing images. The camera resumes taking pictures when the buffer has space again. When you shoot RAW images the maximum consecutive images (until the buffer fills) is six.

Self-Timer/Remote Control ⏱

There are actually two parts to this setting: (1) self-timer and (2) remote control. When you want to be in the picture, the 10-second self-timer is the function to use. Press the shutter button half way and make sure you have achieved focus. Then, press the shutter release button the rest of the way down. A self-timer lamp (located on the front of the camera, built into the camera grip) flashes once a second to count down the seconds. By default, a beep is enabled and sounds during the countdown. Two seconds before the picture is taken, the lamp flashes rapidly and the camera beeps more frequently to let you know the shutter is about to be released. To cancel the countdown, press ◀ ⏱/⏱.

The remote control function should be selected when you use one of Canon's optional wireless remote controls (either the RC-1 or RC-5).

Self-timer:2 sec ⏱2

The 2-second self-timer operates similarly to the 10-second timer in that it takes the picture after a set time. When you shoot with a tripod and have longer shutter speeds, 1/60 and longer, use this quick timer, along with Custom Function (C.Fn) 9, <Mirror lockup>, to reduce camera motion blur.

Self-timer:Continuous ⏱c

The self-timer plus continuous shots setting is new to the XSi. In essence it is the same as a 10-second self-timer except at the end of the countdown the camera takes multiple shots. Use ▲▼ to set the number of shots, from two

120

The classic use of the 10-second self-timer is for the photographer to set up a group shot and then run to get into the picture. The 2-second self-timer is useful to dampen the vibrations from pressing the shutter button when taking landscape photos or still lifes on a tripod.
© Kevin Kopp

to 10. This is a great feature for group shots where you might be concerned if someone has their eyes closed. It also can be fun to capture that moment when everyone stops posing and looks more natural.

Exposure

No matter what technology is used to create a photo, it is always preferable to have the best possible exposure. Digital photography is no exception. A properly exposed digital file is one in which the right amount of light has reached the camera's sensor and produces an image that corresponds to the scene, or to the photographer's interpretation of the scene. This applies to color reproduction, as well as tonal values and subject contrast. The XSi has a sophisticated built-in light meter to read the light in the scene and adjust the exposure settings of the camera.

ISO

ISO (sensitivity) is one control worth knowing so well that its use becomes intuitive. It is vitally important to provide the camera's light meter with information on the sensor's sensitivity to light. The meter can then determine how much exposure is required to properly record the image. Digital cameras adjust the sensitivity of the sensor circuits to settings that can be compared to film of the same ISO speed. (This change in sensitivity involves amplifying the electronic sensor data that creates the image.)

The Rebel XSi offers ISO speed settings of 100-1600. This full ISO range is only available in the Creative Zone exposure modes (see pages 134-143). In the Basic Zone modes (see pages 131-134), ISO is set automatically from 100-800 and you cannot override it.

ISO speed can be set quickly from shot to shot in the Creative Zone. Since sensitivity to light is easily adjustable using a digital SLR, and since the Rebel XSi offers clean images with minimal noise at any standard setting, ISO is a control to use freely so you can rapidly adapt to changing light conditions.

High ISO settings can lead to noise in your pictures. Low ISO settings give the least amount of noise and the best color. Traditionally, film would increase in grain and decrease in sharpness with increased ISO. This is not entirely true with the Rebel XSi because its image is extremely clean. Noise is virtu-

High ISO in low light digital photos has traditionally meant imags with noise. However, the XSi delivers great pictures with very little noise even at higher sensitivities, like this blizzard shot at ISO 1600.
© Haley Pritchard

ally nonexistent at ISO settings of less than 800. Some increase in noise (the digital equivalent of grain) may be noticed as settings of 800 or 1600 are used, but there will be little change in sharpness. Even the settings of 800 and 1600 offer very good results, but make sure you check the image on a computer to see if the noise is acceptable. This opens your digital photography to new possibilities for using slow lenses (lenses with smaller maximum lens openings, which are usually physically smaller as well) and in shooting with natural light.

Setting the ISO: To set the ISO speed, use the ISO button located on the top right shoulder of the camera, immediately behind ⛭ . The ISO Speed Menu displays on the LCD monitor and in the viewfinder. Use ▲▼ or ⛭ to select the sensitivity that you want. Once selected, press (SET) , ISO , or the shutter button. The selected ISO setting appears on the camera settings display on the LCD monitor.

The ISO settings occur in one-stop increments (100, 200, 400, 800, and 1600). Most of the time you will want to choose among several key ISO settings: 100 to capture detail in images of nature, landscape, and architecture; 400 when more speed is needed, such as handholding for portraits when shooting with a long lens; 800 and 1600 when you really need the extra speed under low-light conditions.

Auto ISO: You can also let the XSi decide what ISO to use. One of the options in the ISO Speed Menu is <AUTO>. When selected, the XSi chooses an ISO from a range of 100-800. When you use Flash ⚡ or Manual Exposure **M** modes, the ISO is set to 400. Auto ISO can be used in combination with Aperture-Priority Autoexposure **Av** and Shutter-Priority Autoexposure **Tv** modes (see pages 136-141) to give you enhanced control of exposure settings. For example, if you want the highest shutter speed, set the mode to **Av**, open up the aperture to its widest setting and turn on Auto ISO. This guarantees that the XSi is set for the highest shutter speed.

Metering
In order to produce the proper exposure, the camera's metering system has to evaluate the light. However, even today there is no light meter that produces a perfect exposure in every situation. Because different details of the subject reflect light in different amounts, the Rebel XSi's metering system has been designed with microprocessors and special sensors that give the system optimum flexibility and accuracy in determining exposure.

The camera offers four user-selectable methods of measuring light (metering modes): Evaluative ▣ (linked to any desired AF point), Partial ◙ , Spot ▣ , and Center-weighted Average ▢ . To select a metering mode, press ▲ ▣ (up cross key). The Metering Mode Menu displays on the LCD monitor. Scroll ▲▼ to select the mode you want. Once selected, press ⓢⓔⓣ or the shutter button. The symbol or icon for the type of metering in use appears on the camera settings display on the LCD monitor.

Evaluative Metering ⦿ : The Rebel XSi's Evaluative metering system divides the image area into 35 zones, "intelligently" compares them, and then uses advanced algorithms to determine exposure. The zones come from a grid of carefully designed metering areas that cover the frame, though there are fewer at the edges. Basically, the system evaluates and compares all of the metering zones across the image, noting things like the subject's position in the viewfinder (based on focus points and contrast), brightness of the subject compared to the rest of the image, backlighting, and much more.

As with all Canon EOS cameras, the Rebel XSi's Evaluative metering system is linked to autofocus. The camera actually notes which autofocus point is active and emphasizes the corresponding metering zones in its evaluation of the overall exposure. If the system detects a significant difference between the main point of focus and the different areas that surround this point, the camera automatically applies exposure compensation. (It assumes the scene includes a backlit or spot-lit subject.) However, if the area around the focus point is very bright or dark, the metering can be thrown off and the camera may underexpose or overexpose the image. When your lens is set to manual focus, Evaluative metering uses the center autofocus point.

Note: With Evaluative metering, after autofocus has been achieved, exposure values are locked as long as the shutter button is partially depressed. However, meter readings cannot be locked in this manner if the lens is set for Manual focus. In those cases, use the AE lock button ✶ , located on the back of the camera toward the upper right corner.

It is difficult to capture perfect exposures when shooting extremely dark or light subjects, subjects with unusual reflectance, or backlit subjects. Because the meter theoretically bases its analysis of light on an average gray scene, when subjects or the scene differ greatly from average gray, the meter tends to overexpose or underexpose them. Luckily, you can check exposure information in the viewfinder, or check the image itself on the LCD monitor, and make adjustments as needed.

There are times to move out of Evaluative metering and try a different mode. Partial metering lets the photographer accurately expose for the skin tones without being influenced by the highlights along the left border of this picture. © Haley Pritchard

The main advantage of Evaluative metering over Partial, Spot, and Center-weighted Average metering is that the exposure is biased toward the active AF point, rather than the center of the picture. Plus, Evaluative metering is the only metering mode that automatically applies exposure compensation based on comparative analysis of the scene.

Partial Metering ⬚ : Partial metering covers about 9% of the frame, utilizing the exposure zones at the center of the viewfinder. It allows the photographer to selectively meter portions of a scene and compare the readings in order to select the right overall exposure. This can be an extremely accurate way of metering, but it requires some experience to do well. When you shoot with a telephoto lens, Partial metering acts like Spot metering.

Spot Metering ⊡ : Use this mode to further reduce the area covered for metering. The metering is weighted to the center area (about 4%) of the viewfinder. This can give you an extremely accurate meter reading of a single object in your scene.

Center-Weighted Average Metering ▭ : This method averages the readings taken across the entire scene. In computing the "average exposure", however, the camera puts extra emphasis on the reading taken from the center of the horizontal frame. Since most early traditional SLR cameras used this method exclusively, some photographers have used Center-weighted Average metering for such a long time that it is second nature and they prefer sticking with it. It can be very useful with scenes that change quickly around the subject.

One area in which to be careful with regard to exposure and this camera is the viewfinder eyepiece. This may sound odd, yet if you shoot a long exposure on a tripod and do not have your eye to the eyepiece, there is a good possibility that your photo will be underexposed. The Rebel XSi's metering system is sensitive to light coming through an open eyepiece. To prevent this, Canon has included an eyepiece cover on the camera strap that can be slipped over the viewfinder to block the opening in these conditions. You can quickly check the effect by watching the camera settings on the LCD monitor as you cover and uncover the eyepiece—you'll see how much the exposure can change. You'll need to set the <LCD auto off> function in ｾ to <Disable> (see page 62) to see the display while you cover the eyepiece.

Judging Exposure

The LCD monitor allows you to get an idea of your photo's exposure—it's like using a Polaroid, although not as accurate. With a little practice, however, you can use this small image to evaluate your desired exposure. Recognize that because of the LCD monitor's calibration, size, and resolution, it only gives an indication of what you will actually see when the images are downloaded into your computer.

The XSi's Highlight alert can be set to blink over portions of a photo that show no detail due to overexposure. However, don't be afraid of pictures that exhibit small portions that "blink;" look at the overall photo to judge if it is successful or truly an overexposed image.

The Rebel XSi includes two features—Highlight alert and the histogram—that give you a good indication of whether or not each exposure is correct. These features can be seen on the LCD monitor once an image is displayed there. Push **DISP.** repeatedly to cycle through a series of four displays: (1) Both the image and its exposure information; (2) Similar to previous display (1), but also includes image-recording quality and number of images; (3) A small image with Highlight alert, a histogram (brightness or RGB depending on the histogram setting in **▶**), and extended image information; and (4) A small image with Highlight alert, both the brightness histogram and the RGB histogram, and reduced image information.

Highlight Alert: The camera's Highlight alert is very straightforward: Overexposed highlight areas blink on the small photo displayed next to the histogram. These areas have so much exposure that only white is recorded, no detail. It is

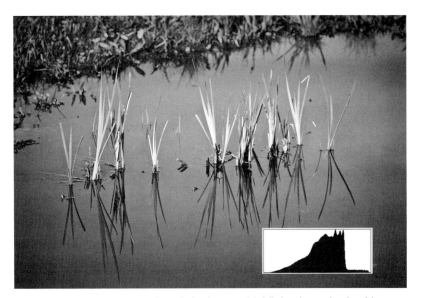

You can eliminate clipping of shadows or highlights by reviewing histograms in the LCD monitor. Adjust exposure as required so the graph moves toward the middle of the left and right axes.

helpful to immediately see what highlights are getting blown out, but some photographers find the blinking a distraction. Blinking highlights are simply information, and not necessarily bad. Some scenes have less important areas that get washed out when the most important parts of the scene are exposed correctly. However, if you discover that significant parts of your subject are blinking, the image is likely overexposed and you need to reduce exposure in some way.

The Histogram: The Rebel XSi's histogram, though small, is an extremely important tool. It is the graph that appears on the LCD monitor next to the image when selected with DISP. during review or playback. The XSi can display two different kinds of histograms: Brightness and RGB. The Brightness histogram allows you to judge the overall exposure of the image, while the RGB histogram focuses in on the individual color channels.

The horizontal axis of the histogram represents the level of brightness—dark areas are at the left, bright areas are at the right. The vertical axis indicates the pixel quantity of the different levels of brightness. If the graph rises as a slope from the bottom left corner of the histogram and then descends towards the bottom right corner, all the tones of the scene are captured.

Consider the graph from left to right (dark to bright). If the graph starts too high on either end, i.e., so the "slope" looks like it is abruptly cut off at either side, then the exposure data is also cut off or "clipped" at the ends because the sensor is incapable of handling the areas darker or brighter than those points. An example would be a dark, shadowed subject on a bright, sunny day.

Or, the histogram may be weighted towards either the dark or bright side of the graph (wider, higher "hills" appear on one side or the other). This is okay if the scene is naturally dark or bright, but if it is not, detail may be lost. However, be careful of dark scenes that have all the data in the left half of the histogram. Such underexposure tends to overemphasize any sensor noise that might be present. You are better off increasing the exposure, even if the LCD image looks bright enough. You can always darken the image in the computer, which will not affect grain; yet lightening a very dark image usually has an adverse effect and results in added noise.

If highlights are important, be sure that the slope on the right reaches the bottom of the graph before it hits the right axis. If darker areas are important, be sure the slope on the left reaches the bottom before it hits the left axis. You really don't have to remember which side is dark or light at first. If you notice an unbalanced graph, just give the scene a change of exposure and notice which way the histogram changes. This is a really good way to learn to read the histogram.

If the scene is low in contrast, the histogram appears as a rather narrow hill in the middle of the graph, leaving gaps with no data toward both left and right axes. To help this sit-

uation, check the Rebel XSi's Picture Styles (see pages 85-
92). Boosting contrast expands the histogram—you can cre-
ate a custom setting with contrast change and tonal curve
adjustments that consistently addresses such a situation. This
can mean better information is captured—it is spread out
more evenly across the tones—before bringing the image
into your computer to use image-processing software. You
could also experiment with C.Fn 6, Auto Lighting Optimizer
(see page 69). Or, you could use RAW, since results are best
in RAW when the data has been stretched to make better use
of the tonal range from black to white.

Note: Auto Lighting Optimizer does not function when
shooting RAW or using manual exposure settings.

When you use the RGB histogram, you can check to see if
any of the individual color channels are over-saturated. Sim-
ilar to the Brightness histogram, the horizontal scale repre-
sents each color channel's brightness level—if more pixels
are to the left, the color is less prominent and darker; to the
right, the color is brighter and denser. If the histogram shows
an abrupt cut-off on either end of the histogram, your color
information is either missing or over saturated. In short, by
checking the RGB histogram, you evaluate the color satura-
tion and white balance bias. Choose which histogram you
want to view in ▣ .

Basic Zone Shooting Modes
The Rebel XSi offers twelve exposure, or shooting, modes
divided into two groups: the Basic Zone and the Creative
Zone. In the Basic Zone, the primary benefit is that the cam-
era can be matched quickly to conditions or to a subject.
Fast and easy to manage, the modes in the Basic Zone per-
mit the camera to predetermine a number of settings. In
some of these modes, all the controls are set by the camera
and cannot be adjusted by the photographer.

All exposure modes, including the Basic Zone modes, are
selected by using the Mode dial ☻ , located on the top
right of the camera. Simply rotate the dial to the icon you

wish to use. Basic Zone modes are identified by a picture icon; Creative Zone modes are selected with the letter icons.

Note: When you are in any of the Basic Zone modes, the ◘ᵀ , ᴵᵞᵗ and ⽅ Menus, as well as various other menu items, are not accessible. In addition, all Basic Zones use JPEG with fine compression, sRGB color space, Auto white balance, Auto ISO, and Evaluative metering.

Full Auto ▢ : The green rectangle selects Full Auto, which is used for completely automatic shooting. This mode essentially converts the Rebel XSi into a point-and-shoot camera—a very sophisticated point-and-shoot! The camera chooses everything; you cannot adjust any controls. This mode is really designed for the beginning photographer who does not trust his or her decisions or for times when you hand the camera to someone to take a picture of you. That way they can't mess up settings. The Picture Style is Standard ᴢ⁺ᴤ , for crisp, vivid images; the drive is set for Single shooting ▢ ; and focus method is set for **AI FOCUS**. The flash fires if needed.

Portrait ❧ : If you like to shoot portraits, this setting is for you. It makes adjustment choices that favor people photography. The drive is set to Continuous ⤶ so you can quickly shoot changing gestures and expressions, while the AF mode is set to **ONE SHOT** so you can lock focus with a slight pressing of the shutter release. The meter favors wider f/stops (those with smaller numbers) because this limits depth of field, offering backgrounds that are softer and therefore contrast with the sharper focus of the subject. A wider f/stop also results in faster shutter speeds, producing sharper handheld images. Picture Style is set to Portrait ᴢ⁺ᴾ for softer skin tones (see page 86).

Landscape ⛰ : When shooting landscape photography, it is important to lock focus on one shot at a time, so Landscape mode uses **ONE SHOT** AF and ▢ Drive mode. The meter favors small f/stops for more depth-of-field (often important for scenic shots). Picture Style is set to Landscape ᴢ⁺ᴸ for vivid greens and blues. The flash does not fire.

132

Close-up mode in the Basic Zone coupled with a macro flash helped keep this scene properly exposed.

Close-Up ❀ : This mode also uses **ONE SHOT** AF and ▢ Drive mode. It favors wider f/stops for faster shutter speeds, giving better sharpness with a handheld camera and far less depth of field in order to set off a sharp subject against a softer background. Picture Style is set to Standard ⬛ . The flash fires if needed.

Sports 🏃 : Designed for action and fast shutter speeds to stop the action of your subject, this uses **AI SERVO** AF and 🔲 Drive mode, both of which allow continuous shooting as action evolves in front of you. In addition, the beep for AF confirmation is softer than other modes. Picture Style is ⬛ . The flash does not fire.

Night Portrait 🌃 : Despite its name, this setting is not limited to nighttime use. It is very useful, even for advanced photographers, to balance flash with low-light conditions.

This setting uses flash to illuminate the subject (which may or may not be a portrait), as well as an exposure to balance the background, bringing in the subject's detail. The latter exposure, called the ambient light exposure, can have a very slow shutter speed and may result in a blurry background, so you may need a tripod if that is not the effect you are going for. The Picture Style is 〔☲▰S〕 .

Flash Off 🚫 : This mode provides a quick and easy setting that prevents the flash from firing. It can be important in museums and other sensitive locations. The Picture Style is 〔☲▰S〕 .

Creative Zone Shooting Modes

The Creative Zone modes offer complete control over camera adjustments and thus encourage a more creative approach to photography. The disadvantage is that there are many possible adjustments, which can be confusing at worst, and time consuming at best. Again, all modes in the Creative Zone are engaged by turning 🕐 to the desired designation, one of the letter icons. Adjustments to the settings, which are displayed on the LCD monitor and viewfinder, are made by turning the Main dial 📷 (top right shoulder of camera).

Remember that Creative Zone settings such as white balance, file type (RAW or JPEG), metering method, focus method, Picture Style, ISO, and drive need to be set manually.

Program AE Mode P : In Program AE (autoexposure) mode, the camera chooses the shutter speed and aperture combination. This gives the photographer less direct control over the exposure because no matter how apt, the settings are chosen arbitrarily (by the camera, not by you). However, you can shift the program by changing either the selected aperture or shutter speed, and the system compensates to maintain the same exposure value. To shift the program, simply press the shutter button halfway, then turn 📷 until the desired shutter speed or aperture value (respectively) is displayed on the LCD monitor or viewfinder. This only works

If there is no wind you can probably choose any shutter speed to shoot flowers or leaves. But the slightest breeze can cause motion blur with these subjects unless your shutter speed is fast enough to freeze the movement.

for one exposure at a time, making it useful for quick-and-easy shooting while retaining some control over camera settings. Program shift does not work with flash.

P selects shutter speed and aperture values steplessly. This means that any shutter speed or aperture within the range of the camera and lens is selected, not just those that are the standard full steps, such as 1/250 second or f/16. This has been common with most SLRs (both film and digital) for many years, and allows for extremely precise exposure accuracy, thanks to the lens' electromagnetically controlled diaphragm and the camera's electronically timed shutter.

Shutter-Priority AE Mode Tv : Tv stands for "time value." In this mode you set the shutter speed (using ⌕) and the camera sets the aperture. If you want a particular shutter speed for artistic reasons—perhaps a high speed to stop action or a slow speed for a blur effect—this is the setting to use. In this mode, even if the light varies, the shutter speed does not. The camera keeps up with changing light by adjusting the aperture automatically. If the aperture indicated in the viewfinder or the LCD monitor is consistently lit (not blinking), the light meter in the XSi has picked a useable aperture. If the maximum aperture (lowest number) blinks, it means the photo will be underexposed. Select a slower shutter speed by turning ⌕ until the aperture indicator stops blinking. You can also remedy this by increasing the ISO setting. If the minimum aperture (highest number) blinks, this indicates overexposure. In this case, you should set a faster shutter speed until the blinking stops, or choose a lower ISO setting.

The Rebel XSi offers a choice of speeds, from 1/4000 second up to 30 seconds in 1/3-stop increments (1/2 stop increments with C.Fn 1; see page 68), plus Bulb setting **BULB**. For flash exposures, the camera syncs at 1/200 second or slower (which is important to know since slower shutter speeds can be used to pick up ambient or existing light in a dimly-lit scene).

Let's examine these shutter speeds by designating them "fast", "moderate", and "slow". (These divisions are arbitrarily chosen, so speeds at either end of a division can really be designated into the groups on either side of it.)

Fast shutter speeds are 1/500–1/4000 second. It wasn't all that long ago that most film cameras could only reach 1/1000 second, so having this range of high speeds on a digital SLR is quite remarkable. The obvious reason to choose these speeds is to stop action. The more the action increases in pace, or the closer it crosses directly in front of you, the higher the speed you need. As mentioned previously, the neat thing about a digital camera is that you

can check your results immediately on the LCD monitor to see if the shutter speed has, in fact, frozen the action.

At these fast speeds, camera movement during exposure is rarely significant unless you try to handhold a super telephoto lens of 600mm (not recommended!). This means, with proper handholding technique, you can shoot using most normal focal lengths (from wide-angle to telephoto up to about 300mm) without blur resulting from camera movement.

Besides stopping action, high shutter speeds allow you to use your lens at its wide openings (such as f/2.8 or f/4) for selective focus effects (shallow depth of field). This is a useful technique. In bright sun, for example, you might have an exposure of 1/200 second at f/16 with an ISO setting of 200. You can get to f/2.8 by increasing your speed by five whole steps of exposure, to approximately 1/4000 second.

Moderate shutter speeds (1/60-1/250 second) work for most subjects and allow a reasonable range of f/stops to be used. They are the real workhorse shutter speeds, as long as there's no fast action. You have to be careful when handholding cameras at the lower end of this range—especially with telephoto lenses—or you may notice blur in your pictures from camera movement during the exposure. Many photographers find that they cannot handhold a camera with moderate focal lengths (50-150mm) at shutter speeds less than 1/125 second without some degradation of the image due to camera movement. You can double-check your technique by taking a photograph of a scene while handholding the camera and then comparing it to the same scene shot using a tripod. Be sure to magnify the image to check for image blur caused by camera motion.

Slow shutter speeds (1/60 second or slower) require something to stabilize the camera. Some photographers may discover they can handhold a camera and shoot relatively sharp images at the high end of this range, but most cannot get optimal sharpness from their lenses at these speeds with-

Exposure settings are related, as demonstrated in this two-picture series. With a slow shutter speed (1/30 second) you get a smaller aperture (higher f/number). Notice the motion blur, as well as how much of the background grass is in focus behind the anemometer.

out a tripod or other stabilizing mount. Slow shutter speeds are used mainly for low-light conditions and to allow the use of a smaller f/stop, for example f/16, creating increased depth of field.

A fun use of very slow shutter speeds (1/8–1/2 second) is to photograph movement, such as a waterfall or runners, or to move the camera during exposure, such as panning it across a scene. The effects are quite unpredictable, but again, image review using the LCD monitor helps. You can try different shutter speeds and see what your images look like. This is helpful when you try to choose a slow speed appropriate for the subject because each speed blurs action differently.

You can set slow shutter speeds (up to 30 seconds) for special purposes, such as capturing fireworks or moonlit

By setting a fast shutter speed (1/1000 second) in Shutter-Priority mode, you get a larger aperture. Notice how much of this background is out of focus and that the action of the spinning anemometer is stopped.

landscapes. Canon has engineered the sensor and its accompanying circuits to minimize noise (a common problem of long exposures with digital cameras) and the Rebel XSi offers remarkable results with these exposures.

In contrast to long exposures using film, long digital exposures are not susceptible to reciprocity. The reciprocity effect comes with film because as exposures lengthen beyond approximately one second (depending on the film), the sensitivity of the film declines, resulting in the need to increase exposure to compensate. A metered 30-second film exposure might actually require double or triple that time to achieve the effect that is desired. Digital cameras do not have this problem. A metered exposure of 30 seconds is all that is actually needed.

Aperture-Priority AE Mode **Av** : In **Av** (aperture value), you set the aperture (the f/stop or lens opening) and the camera selects the appropriate shutter speed for a proper exposure. This is probably the most popular automatic exposure setting among professional photographers.

One of the most common reasons to use **Av** mode is to control depth of field (the distance in front of and behind a specific plane of focus that is acceptably sharp). While the f/stop, or aperture, affects the amount of light entering the camera, it also has a direct effect on depth of field. A small lens opening (higher f/number) such as f/11 or f/16 increases the depth of field in the photograph, bringing objects in the distance into sharper focus when the lens is focused appropriately. Higher f/numbers are great for landscape photography.

A wide lens opening with low f/numbers such as f/2.8 or f/4 decreases the depth of field. These lower f/numbers work well when you want to take a photo of a sharp subject that creates a contrast with a soft, out-of-focus background. If the shutter speed blinks in the viewfinder (or on the LCD monitor), it means good exposure is not possible at that aperture, so determine whether you need to change the aperture or ISO setting.

You can see the effect of the aperture setting on the image by pushing the camera's Depth-of-Field Preview button, located on front of the camera below the lens release button. This stops the lens down to the taking aperture and reveals sharpness in the resulting darkened viewfinder (the lens otherwise remains wide-open until the next picture is taken). Using Depth-of-Field Preview takes some practice due to the darkened viewfinder, but changes in focus can be seen if you look hard enough. You can also check focus in the LCD monitor after the shot (magnify as needed).

A sports or wildlife photographer might choose **Av** mode in order to stop action rather than to capture depth of field. To accomplish this, he or she selects a wide lens opening—perhaps f/2.8 or f/4—to let in the maximum amount of

Aperture-Priority AE mode is a popular way to control depth of field. Here, using f/2.8, your attention is drawn to the kitten's eyes and nose while the rest of her body gently blurs into the background.

light. The camera automatically selects the fastest shutter speed possible for the conditions. Compare this with **Tv** mode. There you can set a fast shutter speed, but the camera still may not be able to expose correctly if the light drops and the selected shutter speed requires an opening larger than the particular lens can provide. (The aperture value blinks in the viewfinder if this is the case.) As a result, photographers typically select **Tv** only when they have to use a specific shutter speed. Otherwise they use **Av** for both depth of field and to gain the fastest possible shutter speed for the circumstances.

Automatic Depth-of-Field AE A-DEP : This is a unique exposure mode that Canon has used on a number of EOS SLRs (both film and digital) over the years. **A-DEP** simplifies the selection of an f/stop to ensure maximum depth of field for a subject. The camera actually checks focus, comparing all

nine AF points to determine the distance between the closest and farthest points in the scene. The camera then picks an aperture to cover that distance and the appropriate shutter speed. You cannot control either yourself. It also sets the focus distance. If the camera cannot get an aperture to match the depth of field needed to cover the near and far points, the aperture blinks. You can check what the depth of field looks like by pressing the Depth-of-field preview button. You must use AF (autofocus) on the lens; MF (Manual Focus) makes the camera act like **P** is set. **A-DEP** does not work with flash. If you turn on the flash the camera again acts like **P** is set.

Manual Exposure Mode M : Not an auto mode, this option is important for photographers who are used to working in full manual and for anyone who faces certain tricky situations. (However, since this camera is designed to give exceptional automatic exposures, I recommend that everyone try the automatic settings at times to see what they can do). In **M** , you set both the shutter speed (using 🕮) and aperture (hold down the Av🔲 button located on back of the camera near the upper right corner of the LCD, then turn the 🕮 dial). You can use the camera's exposure metering system to guide you through manual exposure settings. The current exposure is visible on the scale at the bottom of the viewfinder information display. "Correct" exposure is at the mid-point, and you can see how much the exposure settings vary from that point by observing the scale. The scale shows up to two f/stops over or under the mid-point, allowing you to quickly compensate for bright or dark subjects (especially when using Partial metering). If the pointer on the scale blinks, the exposure is off the scale. Of course, you can also use a hand-held meter.

The following examples of complex metering conditions might require you to use **M** mode: Panoramic shooting (you need a consistent exposure across the multiple shots taken, and the only way to ensure that is with **M** —white balance should be 🔅 , or at least not 🔳); lighting conditions that change rapidly around a subject with consis-

tent light (a theatrical stage, for example); close-up photography where the subject is in one light but slight movement of the camera dramatically changes the light behind it; and any conditions where you need a consistent exposure through varied lighting conditions.

Bulb Exposure BULB: This setting is not on the ⊙ , but is found when the camera is set to **M** as an option following <30 seconds> when you scroll through shutter speeds. This mode allows you to control long exposures because the shutter stays open as long as you keep the shutter button depressed. Let go, and the shutter closes. A dedicated remote switch, such as the Canon RS-60E3, is helpful for these long exposures. It allows you to keep the shutter open without touching the camera (which can cause movement). It attaches to the camera's remote terminal (on the left side). You can use the infrared RC-1 or RC-5 wireless remote switches for Bulb exposures, as well.

When you use **BULB**, the camera shows the elapsed time (in seconds) for your exposure as long as you keep the shutter release or remote switch depressed. This can be quite helpful in knowing your exposure. At this point in digital camera technology, exposures beyond a few minutes start to have problems in the form of excessive noise. Still, the Rebel XSi allows longer exposures than most cameras of this type. It is a good idea to use C.Fn 3, Long exposure noise reduction, to apply added in-camera noise reduction (see page 68). Remember that long exposure noise reduction doubles the apparent exposure time, so make sure you have enough battery power.

AE Lock ✴

AE (autoexposure) lock is a very useful tool in the autoexposure modes. Under normal operation, the camera continually updates exposure either as you move the camera across the scene or as the subject moves. This can be a problem if the light across the area is inconsistent yet remains constant on the subject. In this case, you want to lock the exposure on the subject. AE lock is also helpful when a scene is

Because the camera's meter will reduce exposure in very bright situations, a white church against a bright white sky will lead to an underexposed image where everything turns gray. By adjusting exposure compensation to +1 or higher, the image looks more like the scene as it actually appeared to me.

mostly in one light, yet your subject is in another. In that circumstance, try to find a spot nearby that has the same light as your subject, point the camera at it and lock exposure, then move the camera back to the original composition. (If you have a zoom lens mounted you could zoom in to a particular area of the scene, as well.)

AE lock on the Rebel XSi is similar to that used for most EOS cameras. The ✱ button is located on the back of the camera to the upper right, easily accessed with your thumb. Aim the camera where needed for the proper exposure, then push ✱ . The exposure is locked or secured, and it won't change, even if you move the camera. An asterisk appears in the viewfinder on the left of the information display until the lock is released.

Exposure Compensation Av**☒**

The existence of a feature for exposure compensation, along with the ability to review images in the LCD monitor, means you can quickly get good exposures without using **M** mode. Exposure compensation cannot be used in **M** mode; however, it makes the **P** , **Tv** , **Av** and **A-DEP** modes much more versatile. Compensation is added (for brighter exposure) or subtracted (for darker exposure) in f/stop increments of 1/3 for up to +/- 2 stops (1/2 stop increments with C.Fn 1; see page 68).

To use the exposure compensation feature, start by pressing the shutter button halfway to turn on the metering system. Then press and hold Av**☒** (on back of the camera near the upper right corner of the LCD monitor). Rotate 🗘 to change the compensation amount. The exact exposure compensation appears on the scale at the bottom of the viewfinder information display, as well as on the LCD monitor. (You can also adjust exposure compensation without turning on the metering system by just viewing the camera settings on the LCD monitor while pressing Av**☒** and turning 🗘 .)

It is important to remember that once you set your exposure compensation control, it stays set even if you shut off the camera. Check your exposure setting as a regular habit (by looking at the bottom scale in the viewfinder information display) when you turn on your camera to be sure the compensation is not inadvertently set for a scene that doesn't need it. Turn exposure compensation off (set it to zero) by holding Av**☒** and turning 🗘 to set the scale on the LCD monitor or in the viewfinder back to zero.

With experience, you may find that you use exposure compensation routinely with certain subjects. Since the meter wants to increase exposure on dark subjects and decrease exposure on light subjects to make them closer to middle gray, exposure compensation may be necessary. For example, say you are photographing a high school soccer game with the sun behind the players. The camera wants to

underexpose in reaction to the bright sunlight, but the shaded sides of the players' bodies may be too dark. So you add exposure with the exposure compensation feature. Or maybe the game is in front of densely shaded bleachers. In this case the players would be overexposed because the camera wants to react to the darkness. Here, you subtract exposure. In both cases, the camera consistently maintains the exposure you have selected until you readjust the exposure settings.

The LCD monitor can come in handy when experimenting with exposure compensation. Take a test shot, and then check the photo and its histogram. If it looks good, go with it. If the scene is too bright, subtract exposure; if it's too dark, add it. Again, remember that if you want to return to making exposures without using compensation, you must move the setting back to zero!

Autoexposure Bracketing (AEB): The Rebel XSi offers another way to apply exposure compensation: The Autoexposure Bracketing control (AEB). AEB tells the camera to make three consecutive exposures that are different: (1) A standard exposure (it uses any setting of the exposure compensation function as the standard); (2) An image with less exposure; and (3) One with more exposure. The difference between exposures can be set up to +/- 2 stops in 1/3 stop increments. (C.Fn 1 allows you to change this to 1/2 stop increments.) While using AEB, the Rebel XSi changes the shutter speed in **Tv** mode and aperture in **Av** mode.

AEB is set through **◻•** . Scroll to <AEB>, press ⓢ , then use **◄►** to set the amount. Three dots indicating the range of exposures appear on a small exposure scale on this menu. Make sure you press ⓢ to accept the change.

Note: If C.Fn 1 is set for 1/2-stop increments, you may see more indicators in the viewfinder. This is because the exposure scale in the viewfinder is laid out in 1/3-stop increments and sometimes 1/2-stop indicators are between the hash marks. The LCD monitor is able to redraw the exposure scale.

When in ☐ Drive mode, you have to press the shutter button for each of the three shots. As you shoot, a marker appears on the exposure scale at the bottom of the viewfinder information display. This marker indicates which exposure is being used with the AEB sequence. In 🖳 Drive mode, the camera takes the three shots and stops. When you use ⏱2 and ⏱i , all three shots are taken. With ⏱c , each of the shots at the end of the countdown is bracketed. This means if you set ⏱c for six, you end up with 18 images; however, the camera buffer fills up quickly, so after the first couple shots are taken, the XSi waits until the images in the buffer are written to the memory card before the remaining shots are taken.

Note: When set to AEB, the camera continues to take three different exposures in a row until you reset the control to zero, turn the camera off, change lenses, or replace the SD card or battery.

AEB can help ensure that you get the best possible image files for later adjustment using image-processing software. A dark original file always has the potential for increased noise as it is adjusted, and a light image may lose important detail in the highlights. AEB can help you to determine the best exposure for the situation. You won't use it all the time, but it can be very useful when the light in the scene varies in contrast or is complex in its dark and light values.

AEB is also important for a special digital editing technique that allows you to put multiple exposures together into one master to gain more tonal range from a scene. You can take the well-exposed highlights of one exposure and combine them with the better-detailed shadows of another. (This works best with 1/2 stop bracketing.) If you carefully shot the exposures with your camera on a tripod, they will line up exactly so that when you put the images on top of one another as layers using image-processing software, the different exposures are easy to combine. (You may even want to set the camera to 🖳 —in this mode it takes the three photos for the AEB sequence and then stops.)

You can combine exposure compensation with AEB to handle a variety of difficult situations. But remember, while AEB resets when you turn off the camera, exposure compensation does not.

Live View Shooting

The XSi is the first in the Rebel series of digital SLRs to offer Live View shooting. This technology, which displays an image on the LCD monitor before you shoot, allows you to frame shots when it is difficult to look through the viewfinder. It also allows you to check exposure, composition, color, and focus on a computer display. When the XSi is attached to a computer and you run the Canon-provided software, you view images live on the computer.

Note: Live View only functions in Creative Zone modes.

To turn on Live View shooting, go to 🍴 and scroll to highlight <Live View function settings>, then press ⑤ᴇᴛ. Make sure <Live View shoot.> is highlighted in the subsequent menu screen, again press ⑤ᴇᴛ, then use ▲▼ to highlight <Enable> and press ⑤ᴇᴛ once more to confirm. While in this menu, you can also have the XSi superimpose a grid to help with leveling and image composition. Once Live View shooting is enabled, press ⑤ᴇᴛ at any time to turn it on.

When Live View shooting is turned on, the reflex mirror pops up, rendering the viewfinder unusable. A live image is displayed on the LCD monitor representing 100% coverage of the image that will be recorded. Because the viewfinder does not work, autofocus does not happen as it does with regular shooting, and metering is performed via the image sensor. Autofocus is accomplished either by flipping the mirror back down or by evaluating the image coming from the sensor. C.Fn 8, <AF during Live View shooting>, is used to set autofocus during Live View shooting (see page 70).

Once only an option on point and shoot cameras, Live View on the XSi gives you the ultimate way to preview your image. Now you can see exactly what the sensor sees in real time. © Kevin Kopp

There are three choices in this menu. The first choice is <0: Disable>, which does not allow you to use autofocus in Live View shooting. Because of the time it takes to achieve autofocus, consider selecting <0: Disable> and using manual focus when shooting with Live View.

The next option is <1: Quick mode>. Select the AF point (see page 117) before turning on Live View. Once the AF point has been selected, turn on Live View and compose the shot. Press ✶ and the mirror flips back down, the AF sensors evaluate the scene and set focus and the mirror flips back up. The Live View display should now be in focus. Press the shutter button to take the photograph.

And finally, when C.Fn 8 is set to <2: Live mode>, use ✧ to place the white outline rectangle (Live View AF point) over the portion of the image where you want to lock focus. (Press 🗑 to return the AF point to the center of screen.) Then press ✱ to lock focus. If successful, the AF point changes to green and the camera beeps. If the XSi fails to achieve focus, the AF point turns orange.

Note: You can use 🔍 to magnify the image on the LCD to examine focus in either Live View AF mode. The first press magnifies by 5x, the second by 10x. While the image is magnified, exposure is locked. To reduce magnification you must press 🔍 once or twice to return to normal size. Pressing ▣·🔍 does not exit out of magnification like it does during playback.

There are some limitations using Live View shooting. You can't change drive mode, Picture Style, or select AF points. This doesn't mean you can't use different drive modes, you just can't change them while Live View is functioning. **A-DEP** behaves like **P** . Live View shooting uses a lot of battery power, so make sure you have charged batteries on hand.

You can cycle through three display modes while in Live View. The first display is just the image with the AF point. The second presents a status display showing drive mode, white balance, Picture Style, image-recording quality, AE lock, exposure information, exposure level, flash exposure compensation, shots remaining, battery level, and ISO settings.

Normally the XSi tries to display a viewably bright image on the LCD monitor, no matter how the exposure is set. **Exp.SIM** displays to indicate that the image presented on the LCD monitor (in terms of exposure) is close to the actual exposure that will be captured when the shutter release button is pressed. If this icon blinks, it means the image on the screen does not represent the exposure that will be used for the actual image.

The last display option for Live View shooting adds a histogram chart to the LCD monitor. This live histogram is a powerful tool to evaluate exposure during Live View shooting.

Metering during Live View shooting is preset to [⦿] because it is linked to the Live View AF point and cannot be changed. You can still use all of the exposure and drive modes, however. Adjust ISO, aperture, shutter speed, and exposure compensation just as you would when shooting normally. When you use a Speedlite external flash unit, E-TTL II metering uses the normal meter in the viewfinder, so the mirror must pop down briefly. When you take a picture with flash, the XSi sounds like it is taking two pictures. Flash units other than Canon do not fire.

One XSi feature that is improved with Live View shooting is Depth-of-Field Preview. Normal Depth-of-Field Preview results in a dim viewfinder, making it difficult to see the image. With Live View shooting, as long as the exposure is set for a reasonably correct exposure, when you press the Depth-of-Field Preview button you see a brighter display, which makes it easier to check depth-of-field.

Note: When you use the Live View shooting function, heat can be a problem. Thermal build-up on and near the image sensor causes the function to shut down. This is particularly true when shooting under hot studio lights or outdoors in direct sun. If heat becomes a problem, the camera may shut down and you'll have to wait for the heat to dissipate.

Flash

Electronic flash is not just a supplement for low light; it can also be a wonderful tool for creative photography. Flash is highly controllable, its color is precise, and the results are repeatable. However, the challenge is getting the right look. Many photographers shy away from using flash because they aren't happy with the results. This is because on-camera flash can be harsh and unflattering, and taking the flash off the camera used to be a complicated procedure with less than sure results. The Canon EOS Rebel XSi's sophisticated flash system eliminates many of these concerns and, of course, the LCD monitor gives instantaneous feedback, alleviating the guesswork. With digital, you take a picture and you know immediately whether or not the lighting is right. You can then adjust the light level higher or lower, change the angle, soften the light, color it, and more. Just think of the possibilities:

Fill Flash—Fill in harsh shadows in all sorts of conditions and use the LCD monitor to see exactly how well the fill flash works. Often, you'll want to dial down the output of an accessory flash to make sure the fill is natural looking.

Off-Camera Flash—Putting a flash on a dedicated flash cord allows you to move the flash away from the camera and still have it work automatically. Using the LCD monitor, you can see exactly what the effects are so you can move the flash up or down, left or right, for the best light and shadows on your subject.

Though many people shy away from using external flash units because it seems complicated, it pays to learn about flash photography. Once you can apply some flash techniques, your flash unit becomes a tool that opens more creative avenues for your photography.

Close-Up Flash—This used to be a real problem, except for those willing to spend some time experimenting. Now you can see exactly what the flash does to the subject. This works fantastically well with off-camera flash, as you can "feather" the light (aim it so it doesn't hit the subject directly) to gain control over its strength and how it lights the area around the subject.

Multiple Flashes—Modern flash systems have made exposure with multiple flashes easier and more accurate. However, since the flash units are not on continuously, they can be hard to place so that they light the subject properly. Not anymore. With the Rebel XSi, it is easy to set up the flash, and then take a test shot. Does it look good, or not? Make changes if you need to. In addition, this camera lets you use certain EX-series flash units (and independent brands with the same capabilities) that offer wireless exposure control. This is a good way to learn how to master multiple-flash setups.

Colored Light—Many flashes look better with a slight warming filter, but that is not what this tip is about. With multiple light sources, you can attach colored filters (also called gels) to the various flashes so that different colors light different parts of the photo. (This can be a very trendy look.)

Balancing Mixed Lighting—Architectural and corporate photographers have long used added light to fill in dark areas of a scene so it looks less harsh. Now you can double-check the light balance on your subject using the LCD monitor. You can even be sure the added light is the right color by attaching filters to the flash to mimic or match lights (such as a green filter to match fluorescents).

Flash Synchronization

The Rebel XSi is equipped with an electromagnetically timed, vertically traveling focal-plane shutter that forms a slit to expose the sensor as the slit moves across it. With a focal-plane shutter, the entire surface of the sensor is not exposed

You can control flash to capture creative photos. Use flash exposure compensation to expose your subject properly while letting the background go dark. © Haley Pritchard

at one time when shutter speeds shorter than the flash duration (sync) are used. So, if you use flash with a shutter speed that is shorter than the maximum flash sync speed, the scene is illuminated by the flash for a shorter time than the sensor is exposed, so you get a partially exposed picture. However, at shutter speeds below the maximum sync speed, the whole sensor surface is exposed at some point to accept the flash.

The Rebel XSi's maximum flash sync speed is 1/200 second. If you use a flash and set the exposure to a speed faster than that in **Tv** or **M** mode, the camera automatically resets the speed to 1/200. The camera also offers high-speed sync with EX-series flash units that allow flash at all shutter speeds (even 1/4000 second where, basically, the flash fires continuously as the slit goes down the sensor). High-speed synchronization must be activated on the flash unit itself and

is indicated by an H symbol on the flash unit's LCD panel and in the XSi's viewfinder. See the flash manual for specific information on using high-speed flash sync.

Guide Numbers

It is helpful to compare guide numbers (GN) when you shop for a flash unit because the GN is a simple way to state the power of the unit. It is computed as the product of aperture value and subject distance and is usually included in the manufacturer's specifications for the unit. High numbers indicate more power; however, this is not a linear relationship. Guide numbers act a little like f/stops (because they are directly related to f/stops!) e.g., 56 is half the power of 80, or 110 is twice the power of 80 (see the relationship with f/5.6, f/8, and f/11?).

Since guide numbers are expressed in meters and/or feet, distance is part of the guide number formula. Also, guide numbers are usually based on ISO 100 (film or sensor sensitivity), but this can vary, so check the ISO speed reference (and determine whether the GN was calculated using feet or meters) when you compare different flash units. If you compare units that have zoom-head diffusers, which are special lenses built into the flash units to match flash angle of view with lens angle of view, make sure you compare the guide numbers for similar zoom-head settings.

Built-In Flash

The Rebel XSi's built-in flash pops open to a higher position than the flash on many other cameras. This reduces the chance of getting red-eye and minimizes problems with large lenses blocking the flash. The flash supports E-TTL II (an evaluative autoexposure system), covers a field of view up to a 17mm focal length and has a guide number of 43/13 (ISO 100, in feet/meters). Like most built-in flashes, it is not particularly high-powered, but its advantage is that it is

The built-in flash becomes a useful tool when you are close enough to fill in harsh shadows around the eyes and under the chin, making your photos of family and friends look more natural.

always available and is useful as fill-flash to modify ambient light. Unique to this flash and the Canon Speedlite 580EX II, the flash sends color data to the camera's processor each time it fires. This helps the system measure many variables so it can better maintain consistent color.

The flash pops up automatically in low-light or backlit situations in the following Basic Zone exposure modes: ☐ , 🎭 , 🌷 , and 🖼 . It does not activate in 🏔 , 🏃 , or 🌆 modes. In the Creative Zone, you can choose to use the flash (or not) at any time. Just press the ⚡ button (located on the front of the camera, on the upper left of the lens mount housing) and the flash pops up. To turn it off, simply push the flash down.

The pop-up flash on the XSi is relatively far away from the axis of the camera lens. This helps to minimize red-eye.

The Creative Zone exposure modes do not all use the same approach with the built-in flash. In **P** mode, the flash is fully automatic, setting both an appropriate shutter speed and the aperture. In **Tv** , it can be used when you need a specific shutter speed. In **Av** , the aperture controls the amount of flash used for exposure, the shutter speed influences how much of the ambient (natural) light appears in the image. In **M** , you also set the aperture for the flash, then choose a shutter speed that is appropriate for your subject. (You can use any shutter speed of 1/200 second and slower.)

Flash Metering

The Rebel XSi uses an evaluative autoexposure system, called E-TTL II, with improved flash control over earlier models. (It is based on the E-TTL II system first introduced in the pro-level EOS-1D Mark II.) To understand the Rebel XSi's flash metering, you need to understand how a flash works with a digital camera on automatic. The camera

This frog was hiding in low light under an eave, probably waiting for a spider. With no space to set up a tripod, I used flash so I could set a higher shutter speed and hand hold the camera.

causes the flash to fire twice for the exposure. First, a pre-flash is fired to analyze exposure. Then the flash fires during the actual exposure, creating the image. During the preflash, the camera's Evaluative metering system measures the light reflected back from the subject. Once it senses that the light is sufficient, it cuts off the flash and takes the actual exposure with the same flash duration. The amount of flash that hits the subject is based on how long the flash is on; so close subjects receive shorter flash bursts than more distant subjects. This double flash system works quite well, but you may also find that it causes some subjects to react by closing their eyes during the real exposure. However, they will be well exposed!

Flash with Camera Exposure Modes

You have no control over flash when the camera is set in the Basic Zone. This means you have no say in whether the flash is used for an exposure or how the exposure is controlled. The camera determines it all depending on how it senses the scene's light values. When the light is dim or there is a strong backlight, the built-in flash automatically pops up and fires, except in 🏞 , 🌼 , and ⚡ modes.

In the Creative Zone, you either pop up the built-in flash by pushing ⚡ , or attach an EX Speedlite accessory flash unit and simply switch it to the ON position. The flash operates in the various Creative Zone modes as detailed below.

Program AE P

Flash photography can be used for any photo where supplementary light is needed. All you have to do is turn on the flash unit—the camera does the rest automatically. Canon Speedlite EX flash units should be switched to E-TTL and the ready light should be on, indicating that the flash is ready to fire. While shooting, you must pay attention to make sure the flash symbol ⚡ is visible in the viewfinder, indicating that the flash is charged when you are ready to take your picture. The Rebel XSi sets flash synchronization shutter speeds of 1/60–1/200 second automatically in **P** mode and also selects the correct aperture.

Shutter-Priority AE Tv

This mode is a good choice in situations when you are using flash and want to control the shutter speed. In **Tv** mode, you set the shutter speed before or after a dedicated accessory flash is turned on. All shutter speeds between 1/200 second and 30 seconds synchronize with the flash. With E-TTL flash in **Tv** mode, synchronization with longer shutter speeds is a creative choice that allows you to control the ambient-light background exposure. A portrait of a person at dusk that is shot with conventional TTL flash in front of a building with its lights on would illumi-

Using flash in the Creative Zone gives you more options for controlling exposure than selecting a setting in the Basic Zone. Here I chose an aperture small enough to give increased depth of field. A macro flash helped make sure there was enough contrast to make the butterfly's pattern stand out.

nate the person correctly but would cause the background to go dark. However, using **Tv** mode, you can control the exposure of the background by changing the shutter speed. (A tripod is recommended to keep the camera stable during long exposures).

Aperture-Priority AE Av

Using this mode you can balance the flash with existing light, controlling depth of field in the composition. By selecting the aperture, you are also able to influence the range of the flash. The aperture is selected by turning and watching the external flash's LCD panel until the desired range appears. The camera calculates the lighting conditions and automatically sets the correct flash shutter speed for the ambient light.

Manual Exposure M

Going Manual gives you the greatest number of choices in modifying exposure. The photographer who prefers to adjust everything manually can determine the relationship of ambient light and electronic flash by setting both the aperture and shutter speed. Any aperture on the lens and all shutter speeds between 1/200 second and 30 seconds can be used. If a shutter speed above the normal flash sync speed is set, the Rebel XSi switches automatically to 1/200 second to prevent partial exposure of the sensor.

M mode also offers a number of creative possibilities for using flash in connection with long shutter speeds. You can use zooming effects with a smeared background and a sharply rendered main subject, or take photographs of objects in motion with a sharp "flash core" and indistinct outlines.

A-DEP A-DEP

Using flash with **A-DEP** is the same as shooting in **P** mode.

FE (Flash Exposure) Lock

Autoexposure lock (AE lock, see page 143) on the XSi is a useful tool for controlling exposure in difficult natural lighting situations. Flash exposure (FE) lock offers the same control in difficult flash situations. When either the pop-up flash or an attached flash is turned on, you can lock the flash exposure by pressing the FE lock button ✳ . (This is the same as the AE lock button located on the back of the camera toward the upper right corner.) With an active flash, FE lock causes the camera to emit a preflash whenever pressed, so it calculates the exposure before the shot. It also cancels the preflash that occurs immediately before the actual photograph, thereby reducing the problem with people reacting to that flashing of light a split-second before the actual exposure.

Flash is not only for use indoors, but is valuable outdoors as well to ⇨ *fill shadows when shooting portraits. Position the subject in the center of your viewfinder and press the FE lock button to measure proper flash exposure of your subject. © Kevin Kopp*

To use the FE lock, pop up the flash (or turn on an exter-
nal flash unit), and then lock focus on your subject by press-
ing the shutter button halfway. Next, aim the center of the
viewfinder at the important part of the subject and press the
FE lock button. (**ƒ*** appears in the viewfinder.) Now,
reframe your composition and take the picture. FE lock pro-
duces quite accurate flash exposures.

Using the same principle, you can make the flash weaker
or stronger. Instead of pointing the viewfinder at the subject
to set flash exposure, point it at something light in tone or a
subject closer to the camera. This causes the flash to provide
less exposure. For more light, aim the camera at something
black or far away. With a little experimenting, and by
reviewing the LCD monitor, you can very quickly establish
appropriate flash control for particular situations.

Flash Exposure Compensation
You can also use the Rebel XSi's flash exposure compen-
sation feature to adjust flash exposure by up to +/- 2 stops
in 1/3-stop increments (or 1/2 stop increments if you set
C.Fn 1; see page 68). Flash exposure compensation oper-
ates in similar fashion to the regular exposure compensa-
tion and is accessed via **ƒ** : First highlight <Flash con-
trol> and press ⑅ . Next, highlight <Built-in flash
func. setting> and press ⑅ again. Finally, select
<Flash exp. Comp.> and press ⑅ yet again. A flash
exposure compensation scale is displayed that operates
similar to the exposure compensation scale (pages 38 and
145). The viewfinder displays **⑫** to let you know flash
exposure compensation is enabled.

For the most control over flash, use the camera's **M**
exposure setting. Set an exposure that is correct overall for
the scene, and then turn on the flash. (The flash exposure
is still E-TTL automatic.) The shutter speed (as long as it is
1/200 second or slower) controls the overall light from the
scene (and the total exposure). The f/stop controls the
exposure of the flash. So, to a degree, you can make the
overall scene lighter or darker by changing shutter speed

You can use the camera's red-eye reduction feature, but the best way to eliminate red-eye is to diffuse the flash with a bounce card or move the external flash off camera. © Kevin Kopp

(up to 1/200 second), with no direct effect on the flash exposure. (Note, however, that this does not work with high-speed flash.)

Red-Eye Reduction

In low-light conditions when the flash is close to the axis of the lens (which is typical for built-in flashes), the flash reflects back from the retina of people's eyes (because their pupils are wide). This appears as "red-eye" in the photo. You can reduce the chances of red-eye appearing by using an off-camera flash or by having the person look at a bright light before you shoot (to cause their pupils to constrict). In addition, many cameras offer a red-eye reduction feature that causes the flash to fire a burst of light before the actual exposure, resulting in contraction of the subject's pupils. Unfortunately, this may also result in less than flattering expressions from your subject.

Although the Rebel XSi's flash pops up higher than most, red eye may still be a problem. The Rebel XSi also offers a red-eye reduction feature for flash exposures, but the feature works differently on the XSi than it does on many other cameras. The Rebel XSi uses a continuous light from a bulb next to the handgrip, just below the shutter button (you have to be careful not to block it with your fingers), that helps the subject pose with better expressions. Red-eye reduction is set in the \bullet Menu under <Red-eye On/Off>.

Canon Speedlite EX Flash Units

Canon offers a range of accessory flash units in the EOS system, called Speedlites. While Canon Speedlites don't replace studio strobes, they are remarkably versatile. These highly portable flash units can be mounted in the camera's hot shoe or used off camera with a dedicated cord.

The Rebel XSi is compatible with the EX-series of Speedlites. Units in the EX-series range in power from the Speedlite 580EX II, which has a maximum GN of 190/58 (ISO 100, in feet/meters), to the small and compact Speedlite 220EX, which has a GN of 72/22 (ISO 100, in feet/meters).

Speedlite EX-series flash units offer a wide range of features to expand your creativity. They are designed to work with the camera's microprocessor to take advantage of E-TTL exposure control, extending the abilities of the Rebel XSi considerably.

I strongly recommend Canon's off-camera extension cord for your flash, the shoe cord OC-E3. When you use this, the flash can be moved away from the camera for more interesting light and shadow. You can aim light toward the side or top of a close-up subject for variations in contrast and color. If you find that your subject is overexposed, rather than dialing down the flash (which can be done on certain flash units), just aim the flash a little away from the subject so it doesn't get hit so directly by the light.

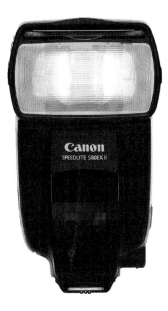

The 580 EX II is Canon's latest generation Speedlite. The communication between the XSi and the 580 EX II makes setting the custom functions of the Speedlite very easy.

Canon Speedlite 580EX II

Introduced with the EOS 1D Mark III professional camera, the 580EX II replaces the popular 580EX. This top-of-the-line flash unit offers outstanding range and features adapted to digital cameras. Improvements over the 580EX include a stronger quick-locking hot shoe connection, stronger battery door, dust and water resistance, a shorter and quieter recycling time, and an external metering sensor. The tilt/swivel zoom head on the 580EX II covers focal lengths from 14mm to 105mm, and it swivels a full 180 degrees in either direction. The zoom positions (which correspond to the focal lengths 24, 28, 35, 50, 70, 80, and 105mm) can be set manually or automatically (the flash reflector zooms with the lens). In addition, this flash "knows" what size sensor is used with a digital SLR and varies its zoom accordingly. With the built-in retractable diffuser in place, the flash coverage is wide enough for a 14mm lens. It provides a high flash output with a GN of 190/58 (at ISO 100 in feet/meters) when the zoom head is positioned at 105mm. The guide number decreases as the angular coverage increases for shorter focal lengths, but is still quite high with a GN of

Multiple slave flashes all triggered by the master 580EX II reduce shadows and make for a soft, even light.

145/44 (ISO 100 in feet/meters) at 50mm, or a GN of 103/32 (ISO 100 in feet/meters) at 28mm. When used with other flashes, the 580EX II can function either a master flash or a slave unit (see page 173).

Also new to the 580EX II is a PC terminal for use with PC cords. For external power, a new power pack, LP-E4, has been developed that is dust and water-resistant.

The large, illuminated LCD panel on the 580EX II provides clear information on all settings: flash function, reflector position, working aperture, and flash range in feet or meters. The flash also includes a Select dial for easier selection of these settings. When you press the XSi's Depth-of-field preview button (front of camera, on lower right of the lens mount housing), a one-second burst of light is emitted. This modeling flash allows you to judge the effect of the flash. The 580EX II also has 14 user-defined custom settings

The 580EX II external flash is a great accessory for the Rebel XSi.

that are totally independent of the camera's Custom Functions; for more information, see the flash manual.

While the LCD panel on the 580EX II provides a lot of information, it can be a little complicated if you try to adjust the various settings and custom functions when you don't use the flash every day. Canon came up with a great solution: You can use the XSi menu system to access the 580EX II's controls. The Custom Functions appear as numeric codes on the Speedlite's LCD. But within the XSi External flash control system, those Custom Functions have names and descriptions, just like the XSi's own Custom Functions. The same is true when you adjust other flash functions such as Flash mode, flash exposure compensation, flash exposure bracketing and many more. You can also adjust the flash zoom head setting and wireless E-TTL setting from the camera. With this new intelligence, it has never been easier to learn how to use Canon Speedlites to capture great images.

Canon Speedlite 430EX

The 430EX is less complicated, more compact, and less expensive than the 580EX II. It offers E-TTL flash control, wireless E-TTL operation, flash exposure compensation, and high-speed synchronization. The 430EX flash unit provides high performance with a GN of 141/43 (ISO 100 in feet/meters) with the zoom reflector set for 105mm. The tilt/swivel zoom reflector covers focal lengths from 24 to 105mm. The zoom head operates automatically for focal lengths of 24, 28, 35, 50, 70, 80, and 105mm. A built-in wide-angle pull-down reflector makes flash coverage wide enough for a 17mm lens. An LCD panel on the rear of the unit makes adjusting settings easy, and there are six Custom Functions that are accessible. Since the 430EX supports wireless E-TTL, it can be used as a remote, or slave, unit. The 430EX does not offer the menu control from the XSi that the 580EX II does

Other Speedlites

The Speedlite 220EX is an economy alternative EX-series flash. It offers E-TTL flash and high-speed sync, but does not offer wireless flash or exposure bracketing.

Close-Up Flash

There are also two specialized flash units for close-up photography that work well with the EOS Rebel XSi. Both provide direct light on the subject.

Macro Twin Lite MT-24EX: The MT-24EX uses two small flashes affixed to a ring that attaches to the lens. These can be adjusted to different positions to alter the light and can be used at different strengths so one can be used as a main light and the other as a fill light. If both flash tubes are switched on, they produce a GN of 72/22 (ISO 100 in feet/meters), and when used individually, the guide number is 36/11 (feet/meters). It does an exceptional job with directional lighting in macro shooting.

Macro Ring Lite MR-14EX: Like the MT-24EX, the MR-14EX uses two small flashes affixed on a ring. It has a GN of 46/14 (ISO 100 in feet/meters), and both flash tubes can be

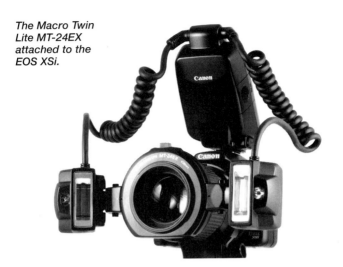

The Macro Twin Lite MT-24EX attached to the EOS XSi.

independently adjusted in 13 steps from 1:8 to 8:1. It is a flash that encircles the lens and provides illumination on axis with it. This results in nearly shadowless photos because the shadow falls behind the subject compared to the lens position, though there will be shadow effects along curved edges. It is often used to show fine detail and color in a subject, but it cannot be used for varied light and shadow effects. This flash is commonly used in medical and dental photography so that important details are not obscured by shadows.

The power pack for both of these specialized flash units fits into the flash shoe of the camera. In addition, both macro flash units offer some of the same technical features as the 580EX II, including E-TTL operation, wireless E-TTL flash, and high-speed synchronization. Both units can also be used as master controllers for wireless E-TTL flash.

Note: When the Rebel XSi is used with older system flash units (such as the EZ series), the flash unit must be set to manual, and TTL does not function. For this reason, Canon EX Speedlite system flash units are recommended for use with the camera.

Directing an external flash to bounce the light off of a low ceiling or nearby wall softens and diffuses the light, usually resulting in more pleasing photos. But be sure the ceiling or wall is light colored, or you may end up with a color cast in your image.

Bounce Flash

Direct flash can often be harsh and unflattering, causing heavy shadows behind the subject or underneath features such as eyebrows and bangs. Bouncing the flash softens the light and creates a more natural-looking light effect. The Canon Speedlite 580EX II and 430EX accessory flash units feature heads that are designed to tilt so that a shoe-mounted flash can be aimed at the ceiling to produce soft, even lighting. The 580EX II also swivels 180 degrees in both directions, so the light can be bounced off something to the side of the camera, like a wall or reflector. However, the ceiling or wall must be white or neutral gray, or it may cause an undesirable color cast in the finished photo.

Wireless E-TTL Flash

With the Wireless E-TTL feature, you can use up to three groups of Speedlite 580EX IIs, 430EXs, or the now discontinued 580EXs, 550EXs, and 420EXs, for more natural lighting or emphasis. (The number of flash groups is limited to three, but the number of actual flash units is unlimited.) The master unit and the camera control the exposure. When you use the 580EX II control, you can set it to be the master, controlling all the other flashes, or a slave. The 430EX can only be used as a remote (slave) unit. Other wireless flash options include the Speedlite infrared transmitter (ST-E2), which only acts as a controller mounted on the XSi (it does not emit light to illuminate a scene), the Macro Twin Lite MT-24EX, or the Macro Ring light MR-14EX.

To operate wireless E-TTL, a Speedlite 580EX II (or the ST-E2, 580EX, or 550EX) is mounted in the flash shoe on the camera and the unit set so that it functions as a master unit. Next, the slave units are set up in the surrounding area. The light ratio of slave units can be varied manually or automatically. With E-TTL (wireless) control, several different Speedlite 420EXs, 430EXs, 550EXs, 580Exs and 580EX IIs can be controlled at once.

Lenses and Accessories

The Rebel XSi belongs to an extensive family of Canon EOS-compatible equipment, including lenses, flashes, and other accessories. With this wide range of available options, you can expand the capabilities of your camera quite easily. Canon has long had an excellent reputation for its lenses, and offers over 60 different lenses to choose from. Several independent manufacturers offer quality Canon-compatible lenses as well.

The Rebel XSi can use both Canon EF and EF-S lenses, ranging from wide-angle to tele-zoom, as well as single-focal-length lenses, from very wide to extreme telephoto. Keep in mind, however, that standard 35mm focal lengths do not act on most digital cameras the way they did with film. This is because most digital sensors are smaller than a frame of 35mm film, so they crop the area seen by the lens, essentially creating a different format. Effectively, this magnifies the subject within the image area of the Rebel XSi and results in the lens acting as if it has been multiplied by a factor of 1.6 compared to 35mm film cameras.

So, both the widest angle and the farthest zoom focal lengths are multiplied by the Rebel XSi's 1.6x focal length conversion factor. The EF 14mm f/2.8 L lens, for example, is a super-wide lens when used with a 35mm film camera or a full-framed sensor like that found in the EOS 5D, but offers the 35mm-format equivalent of a 22mm wide-angle lens (14 multiplied by 1.6) when attached to the EOS Rebel XSi—wide, but not super-wide. On the other hand, put a 400mm lens on the Rebel XSi and you get the equivalent of a 640mm telephoto—a big boost with no change in aperture. (Be sure to use a tripod for these focal lengths!)

A telephoto zoom lens helps you get closer pictures of wildlife without scaring away your subjects. In fact, because of its sensor size, the XSi crops images so they appear even larger than they used to with a 35mm SLR. This is a bonus at the telephoto end of a zoom. © Marianne Wallace

It is interesting to note that this is exactly the same thing that happens when one focal length is used with different sized film formats. For example, a 50mm lens is considered a mid-range focal length for 35mm, but it would be a wide-angle for medium format cameras. The focal length of the lens doesn't really change, but the field of view that the camera captures changes.

Note: Unless stated otherwise, I refer to the actual focal length of a lens throughout the rest of the chapter, not its 35mm equivalent.

Choosing Lenses

The focal length and design of a lens have a huge effect on how you photograph. The correct lens makes photography a joy; the wrong one makes you leave the camera at home. One approach for choosing a lens is to determine if you are frustrated with your current lens. Do you constantly want to see more of the scene than the lens allows? Then consider a wider-angle lens. Is the subject too small in your photos? Then look into acquiring a zoom or telephoto lens. Do you need more light-gathering ability? Maybe a fixed-focal length lens is needed.

Certain subjects lend themselves to specific focal lengths. Wildlife and sports action are best photographed using focal lengths of 200mm or more, although nearby action can be managed with focal lengths as short as 125mm. Portraits look great when shot with focal lengths between 50 and 65mm. Interiors often demand wide-angle lenses, such as 12mm. Many people also like wide-angles for landscapes, but telephotos can come in handy for distant scenes. Close-ups can be shot with nearly any focal length, though skittish subjects such as butterflies might need a rather long lens.

The inherent magnification factor is great news for the photographer who needs long focal lengths for wildlife or sports. A standard 300mm lens for 35mm film now acts like

While long telephoto lenses have always been popular to bring far objects closer, a wide-angle lens is a great option for creative photography.

a 480mm lens on the Rebel XSi. You get a long focal length in a smaller lens, often with a wider maximum f/stop, and with a much lower price tag. But this news is tough for people who need wide-angles, since the width of what the digital camera sees is significantly cropped in comparison to what a 35mm camera would see using the same lens. You need lenses with shorter focal lengths to see the same amount of wide-angle you may have been used to with film.

Zoom vs. Prime Lenses

When zoom lenses first came on the market, they were not even close to a single-focal-length lens in sharpness, color rendition, or contrast. Today, you can get superb image quality from either type. There are some important differences, though. The biggest is maximum f/stop.

Zoom lenses are rarely as fast (e.g. rarely have as big a maximum aperture) as single-focal-length (prime) lenses. A 28-200mm zoom lens, for example, might have a maximum aperture at 200mm of f/5.6, yet a single-focal-length lens might be f/4 or even f/2.8. When zoom lenses come close to a single-focal-length lens in f/stops, they are usually considerably bigger and more expensive than the single-focal-length lens. Of course, they also offer a whole range of focal lengths, which a single-focal-length lens cannot do. There is no question that zoom lenses are versatile.

EF-Series Lenses

Canon EF lenses include some unique technologies. Canon pioneered the use of tiny autofocus motors in its lenses. In order to focus swiftly, the focusing elements within the lens need to move with quick precision. Canon developed the lens-based ultrasonic motor for this purpose. This technology makes the lens motor spin with ultrasonic oscillation energy instead of the conventional drive-train system (which tends to be noisy). This allows lenses to autofocus nearly instantly with no noise and it uses less battery power than traditional systems. Canon lenses that use this motor are labeled USM. (Lower-priced Canon lenses have small motors in the lenses too, but they don't use USM technology, and can be slower and noisier.)

Canon was also a pioneer in the use of image-stabilizing technologies. IS (Image Stabilizer) lenses utilize sophisticated motors and sensors to adapt to slight movement during exposure. It's pretty amazing—the lens actually has vibration-detecting gyrostabilizers that move a special image-stabilizing lens group in response to lens movement. This dampens movement that occurs from handholding a camera and allows much slower shutter speeds to be used. IS also allows big telephoto lenses (such as the EF 500mm IS lens) to be used on tripods that are lighter than would normally be used with non-IS telephoto lenses.

The IS technology is part of many zoom lenses, and does a great job overall. However, IS lenses in the mid-focal length ranges have tended to be slower zooms when matched against single-focal-length lenses. For example, compare the EF 28-135mm f/3.5-5.6 IS lens to the EF 85mm f/1.8. The former has a great zoom range, but allows less light at maximum aperture. At 85mm (a good focal length for people), the EF 28-135mm is an f/4 lens, more than two stops slower than the f/1.8 single-focal-length lens, when both are shot "wide-open" (typical of low light situations). While you could make up the two stops in "handholdability" due to the IS technology, that also means you must shoot two full shutter speeds slower, which can be a real problem in stopping subject movement.

EF-S Series Lenses

EF lenses are the standard lenses for all Canon EOS cameras. EF-S lenses are small, compact lenses designed for use on digital SLRs with smaller-type sensors (such as the EOS 20D, 30D, 40D, the EOS Digital Rebel, the Rebel XT, the Rebel XTi and the Rebel XSi). They were introduced with the EF-S 18-55mm lens packaged with the original EOS Digital Rebel. They cannot be used with film EOS cameras or with any of the EOS-1D cameras (1D, 1Ds, 1D Mark II, 1Ds Mark II, 1D Mark III, and the 1Ds Mark III) because the image area for each of those cameras' sensors is larger than that of the Rebel XSi's sensor.

Canon's EF-S 17-55 f/2.8 IS USM is image stabilized and specifically designed for digital sensors that are less than full framed in size.

Note: While these lenses are designed specifically for cameras with smaller image sensors, focal length is still focal length. It is incorrect to assume that the focal lengths have been "adjusted" for the smaller sensors. This means that the 1.6x conversion factor still applies when using EF-S lenses on the XSi.

Currently Canon has six EF-S lenses. The EF-S 17-85mm f/4-5.6 IS USM is an image-stabilized zoom in a compact package. The EF-S 17-55 f/2.8 IS USM offers an image-stabilized zoom with a wide aperture. A newly introduced EF-S 18-55mm f/3.5-5.6 IS is the kit lens that is often sold with the XSi.

The EF-S 10-22mm f/3.5-4.5 USM zoom brings an excellent wide-angle range to the Rebel XSi. For macro shooting Canon offers the EF-S 60mm f/2.8 Macro USM that focuses down to life-size magnification. On the opposite end of the lens spectrum is the newly introduced EF-S 55-250mm f/4-5.6 IS which offers a very useful telephoto range.

This image-stabilized EF 16–35mm f/2.8L II USM zoom lens provides consistent aperture throughout the focal range.

L-Series Lenses

Canon's L-series lenses use special optical technologies for high-quality lens correction, including low-dispersion glass, fluorite elements, and aspherical designs. UD (ultra-low dispersion) glass is used in telephoto lenses to minimize chromatic aberration, which occurs when the lens cannot focus all colors equally at the same point on the sensor (or on the film in a traditional camera), resulting in less sharpness and contrast. Low-dispersion glass focuses colors more equally for sharper, crisper images.

Fluorite elements are even more effective (though more expensive) and have the corrective power of two UD lens elements. Aspherical designs are used with wide-angle and mid-focal length lenses to correct the challenges of spherical aberration in such focal lengths. Spherical aberration is a problem caused by lens elements with extreme curvature (usually found in wide-angle and wide-angle zoom lenses). Glass tends to focus light differently through different parts of such a lens, causing a slight, overall softening of the image even though the lens is focused sharply. Aspherical lenses use a special design that compensates for this optical defect.

181

Because of the Diffractive Optics, this zoom lens gives a great telephoto range without the bulk of a standard telephoto. It is a great walking-around lens.

DO-Series Lenses

Another Canon optical design is the DO (diffractive optic). This technology significantly reduces the size and weight of a lens, and is therefore useful for big telephotos and zooms. Yet, the lens quality is unchanged. The lenses produced by Canon in this series are a 400mm pro lens that is only two-thirds the size and weight of the equivalent standard lens, and a 70-300mm IS lens that offers a great focal length range while including image stabilization.

Macro and Tilt-Shift Lenses

Canon also makes some specialized lenses. Macro lenses are single-focal-length lenses optimized for high sharpness throughout their focus range, from very close (1:1 or 1:2) magnifications to infinity. These lenses range from 50mm to 180mm.

Tilt-shift lenses are unique lenses that shift up and down or tilt toward or away from the subject. They mimic the controls of a view camera. Shift lets the photographer keep the back of the camera parallel to the scene and move the lens to get a tall subject into the composition. This keeps vertical lines vertical and is extremely valuable for architectural photographers. Tilt changes the plane of focus so that sharpness

Independent lens brands can range from simple zoom lenses to this special lens called a Lensbaby. It is a selective focus lens that attaches directly to the XSi and offers extraordinary creative control over focus and blur.

can be changed without changing the f/stop. Focus can be extended from near to far by tilting the lens toward the subject, or sharpness can be limited by tilting the lens away from the subject (which has been a trendy advertising photography technique lately).

Independent Lens Brands

Independent lens manufacturers also make some excellent lenses that fit the Rebel XSi. I've seen quite a range in capabilities from these lenses. Some include low-dispersion glass and are stunningly sharp. Others may not match the best Canon lenses, but offer features (such as focal length range or a great price) that make them worth considering. To a degree, you get what you pay for. A low-priced Canon lens probably won't be much different than a low-priced independent lens. On the other hand, the high level of engineering and construction found on a Canon L-series lens can be difficult to match.

Filters

Many people assume that filters aren't needed for digital photography because adjustments for color and light can be made in the computer. By no means are filters obsolete! They actually save a substantial amount of work in the digital darkroom by allowing you to capture the desired color and tonalities for your image right from the start. Even if you can do certain things in the computer, why take the time if you can do them more efficiently while shooting?

If you aren't sure how a filter works, simply try it and see the results immediately on the LCD monitor. Just take the shot, review it, and make adjustments to the exposure or white balance to help the filter do its job. If a picture doesn't come out the way you would like, discard it and take another right away.

Attaching filters to the camera depends entirely on your lenses. Usually, a properly sized filter can either be screwed directly onto a lens or fitted into a holder that screws onto the front of the lens. There are adapters to make a given size filter fit several lenses, but the filter must cover the lens from edge to edge or it will cause dark corners in the photo (vignetting). There are a number of different types of filters that perform different tasks.

Polarizers

This important outdoor filter should be in every camera bag. Its effects cannot be duplicated exactly with software because it actually affects the way light is perceived by the sensor.

A polarizer darkens skies when used at an angle that is 90° to the sun (this is a variable effect), reduces glare (which often makes colors look better), removes reflections, and increases saturation. While you can darken skies on the computer, the polarizer reduces the amount of work you have to perform in the digital darkroom. The filter can rotate in its mount, and as it rotates, the strength of the effect changes. While linear polarizers often have the strongest

A circular polarizer is a great choice on those days when you see puffy clouds in a deep blue sky. Notice its effect in the bottom picture.

effect, they can cause problems with exposure, and often prevent the camera from autofocusing. Consequently, you are safer using a circular polarizer with the Rebel XSi.

The daytime sky is often much brighter than the rest of the scene. These two pictures were taken at the same time in the same location. The image above is a normal exposure where the camera meter adjusts for the bright sky, leaving the foreground underexposed. If I used exposure compensation, the sky would be overexposed and cloud detail would be lost.

Neutral Density Gray Filters

Called ND filters, this type is a helpful accessory. ND filters simply reduce the light coming through the lens. They come in different strengths, each reducing different quantities of light. They give additional exposure options under bright conditions, such as a beach or snow (where a filter with a strength of 4x is often appropriate). If you like the effects when slow shutter speeds are used with moving subjects, a strong neutral density filter (such as 8x) usually works well. Of course, the great advantage of the digital camera, again, is that you can see the effects of slow shutter speeds immediately on the LCD monitor so you can modify your exposure for the best possible effect.

186

The solution was to use a neutral density graduated filter and place the filter transition right at the horizon (above). This darkens the sky, giving it more drama while allowing the foreground to be exposed properly.

Graduated Neutral Density Filters

Many photographers consider this filter an essential tool. It is half clear and half dark (gray). It is used to reduce bright areas (such as sky) in tone, while not affecting darker areas (such as the ground). The computer can mimic its effects, but you may not be able to recreate the scene you wanted. A digital camera's sensor can only respond to a certain range of brightness at any given exposure. If a part of the scene is too bright compared to the overall exposure, detail is washed out and no amount of work in the computer will bring it back. While you could try to capture two shots of the same scene at different exposure settings and then combine them on the computer, a graduated ND might be quicker.

UV and Skylight Filters

Though many amateur photographers buy these, pros rarely use them. The idea behind them is to give protection to the front of the lens, but they do very little visually. Still, they can be useful when photographing under such conditions as strong wind, rain, blowing sand, or going through brush.

If you use a filter for lens protection, a high-quality filter is best, as a cheap filter can degrade the optical quality of the lens. Remember that the manufacturer made the lens/sensor combination with very strict tolerances. A protective filter needs to be literally invisible, and only high-quality filters can guarantee that.

Close-Up Lenses

Close-up photography is a striking and unique way to capture a scene. Most of the photographs we see on a day-to-day basis are not close-ups, making those that do make their way to our eyes all the more noticeable. It is surprising to me that many photographers think the only way to shoot close-ups is with a macro lens. The following are four of the most common close-up options:

- **Close-focusing zoom lenses with a macro or close-focus feature**—Most zoom lenses allow you to focus up-close without accessories, although focal-length choices may become limited when using the close-focus feature. These lenses are an easy and effective way to start shooting close-ups. Keep in mind, however, that even though these may say they have a macro setting, it is really just a close-focus setting and not a true macro as described below in option four.

You don't need a true macro lens to take close-up photographs. ⇨
Many zoom lenses allow you to focus close to your subject. You can also purchase close-up filters and extension tubes to use with some of your existing lenses to decrease the minimum focus distance.

- **Close-up accessory lenses**—You can buy lenses that screw onto the front of your lens to allow it to focus even closer. The advantage is that you now have the whole range of zoom focal lengths available and there are no exposure corrections. Close-up filters can do this, but the image quality is not great. More expensive achromatic accessory lenses (highly-corrected, multi-element lenses) do a superb job with close-up work, but their quality is limited by the original lens.

- **Extension tubes**—Extension tubes fit in between the lens and the camera body of an SLR. This allows the lens to focus much closer than it could normally. Extension tubes are designed to work with all lenses for your camera (although older extension tubes won't always match some of the new lenses made specifically for digital cameras). Be aware that extension tubes cause a loss of light.

- **Macro lenses**—Though relatively expensive, macro lenses are designed for superb sharpness at all distances and will focus from mere inches to infinity. In addition, they are typically very sharp at all f/stops.

Close-Up Sharpness

Sharpness is a big issue with close-ups, and this is not simply a matter of buying a well-designed macro lens. The other close-up options can also give superbly sharp images. Sharpness problems usually result from three factors: limited depth of field, incorrect focus placement, and camera movement.

The closer you get to a subject, the shallower depth of field becomes. You can stop your lens down as far as it will go for more depth of field. Because of this, it is critical to be sure focus is placed correctly on the subject. If the back of an insect is sharp but its eyes aren't, the photo appears to have a focus problem. At these close distances, every detail counts. If only half of the flower petals are in focus, the overall photo does not look sharp. Autofocus up close can be a real problem with critical focus placement because the camera often focuses on the wrong part of the photo.

Of course, you can review your photo on the LCD monitor to be sure the focus is correct before leaving your subject. You can also try manual focus. One technique is to focus the lens at a reasonable distance, then move the camera toward and away from the subject as you watch it go in and out of focus. This can really help, but still, you may find that taking multiple photos is the best way to guarantee proper focus at these close distances. Another good technique is to shoot using ⊒ᴵ Drive mode and fire multiple photos. You may find at least one shot with the critical part of your subject in focus. This is a great technique when you are handholding and when you want to capture moving subjects.

When you are focusing close, even slight movement can shift the camera dramatically in relationship to the subject. The way to help correct this is to use a high shutter speed or put the camera on a tripod. Two advantages to using a digital camera during close-up work are the ability to check the image to see if you are having camera movement problems, and the ability to change ISO settings from picture to picture (enabling a faster shutter speed if you deem it necessary).

Close-Up Contrast
The best looking close-up images are often ones that allow the subject to contrast with its background, making it stand out and adding some drama to the photo. Although maximizing contrast is important in any photograph where you want to emphasize the subject, it is particularly critical for close-up subjects where a slight movement of the camera can totally change the background.

There are three important contrast options to keep in mind:

- **Tonal or brightness contrasts**—Look for a background that is darker or lighter than your close-up subject. This may mean a small adjustment in camera position. Back-light is excellent for this since it offers bright edges on your subject with lots of dark shadows behind it.

- **Color contrasts**—Color contrast is a great way to make your subject stand out from the background. Flowers are popular close-up subjects and, with their bright colors, they are perfect candidates for this type of contrast. Just look for a background that is either a completely different color (such as green grass behind red flowers) or a different saturation of color (such as a bright green bug against dark green grass).

- **Sharpness contrast**—One of the best close-up techniques is to work with the inherent limit in depth of field and deliberately set a sharp subject against an out-of-focus background or foreground. Look at the distance between your subject and its surroundings. How close are other objects to your subject? Move to a different angle so that distractions do not conflict with the edges of your subject. Try different f/stops to change the look of an out-of-focus background or foreground.

This image shows contrast between light and dark as well as between *sharp foreground and out-of-focus background. In large part, the effects are a result of patience: I waited for the sun to break through the trees and highlight this dew-covered grass before I took the picture.*

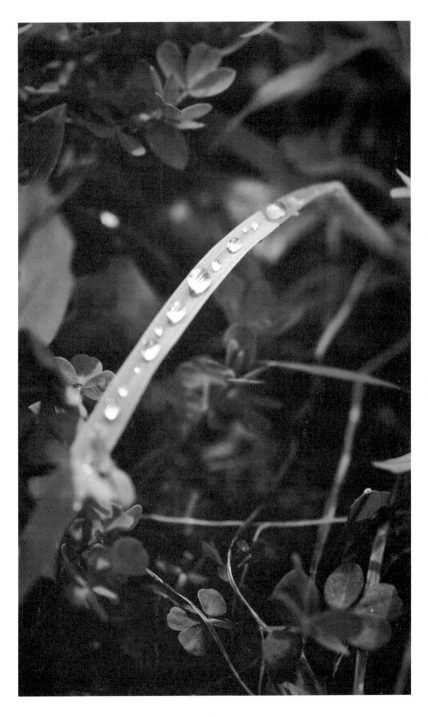

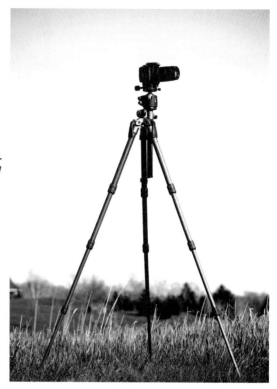

Even though a number of Canon lenses are image stabilized, the importance of a good tripod cannot be overemphasized as a key to creating sharp images. Invest in a well-built tripod and it can last a lifetime.

Tripods and Camera Support

A successful approach to getting the most from a digital camera is to be aware that camera movement can affect sharpness and tonal brilliance in an image. Even slight movement during the exposure can cause the loss of fine details and the blurring of highlights. These effects are especially glaring when you compare an affected image to a photo that has no motion problems. In addition, affected images do not enlarge well.

You must minimize camera movement in order to maximize the capabilities of your lens and sensor. A steady hold on the camera is a start. Fast shutter speeds, as well as the use of flash, help to ensure sharp photos, although you can

With the camera set to the Self-timer Drive mode, the RC-5 wireless remote control will trip the shutter after a two-second delay, insuring lack of vibration that could cause blur in your pictures.

get away with slower shutter speeds when using wider-angle lenses. When shutter speeds go down, however, it is advisable to use a camera-stabilizing device. Tripods, beanbags, monopods, mini-tripods, shoulder stocks, clamps, and more, all help. Many photographers carry a small beanbag or a clamp pod with their camera equipment for those situations where the camera needs support but a tripod isn't available.

Check your local camera store for a variety of stabilizing equipment. A good tripod is an excellent investment. When buying one, extend it all the way to see how easy it is to open, then lean on it to see how stiff it is. Both aluminum and carbon fiber tripods offer great rigidity. Carbon fiber is much lighter, but also more expensive. A new option that is in the middle in price/performance between aluminum and carbon fiber is basalt. Basalt tripods are stronger than aluminum but not quite as light as carbon fiber.

The head is a very important part of the tripod and may be sold separately. There are two basic types for still photography: the ball head and the pan-and-tilt head. Both designs are capable of solid support and both have their passionate advocates. The biggest difference between them is how you loosen the controls and adjust the camera. Try both and see which seems to work better for you. Be sure to do this with a camera on the tripod because that added weight changes how the head works.

Working with Files
in the Computer

Congratulations. You've put your skills to the task and have
taken advantage of your XSi's sophisticated features to
shoot a number of fine photographs. Now you want to
develop them a little further with image-processing soft-
ware in the computer, as well as store and catalog them for
future access.

To enhance your image files in the computer, you need to
duplicate your pictures from the memory card into the com-
puter. There are two primary ways of doing this. One way is
to insert the card into an accessory known as a media card
reader. Card readers connect to your computer through the
USB or FireWire port and can remain plugged in and ready
to download your pictures. The second way is to download
images directly from the Rebel XSi using a USB interface
cable (included with the camera at the time of purchase).

FireWire (also called iLink or 1394) is faster than some
USB but it might not be standard on your computer. There
are several types of USB: USB 1.0, USB 2.0, and USB 2.0
Hi-Speed. Older computers and card readers may have the
1.0 version, but new devices are most likely 2.0 Hi-Speed.
This new version of USB is much faster than the old. How-
ever, if you have both versions of USB devices plugged into
the same bus, the older devices will slow down the speed of
the faster devices.

*Proper exposure and composition is only half the story. Knowing
how to work with your images once they are on your computer is the
other half.*

The advantage of downloading directly from the camera is that you don't need to buy a card reader. However, there are some distinct disadvantages. For one, cameras generally download much more slowly than card readers (given the same connections). Plus, a camera has to be unplugged from the computer after each use, while the card reader can be left attached. In addition to these drawbacks, downloading directly from a camera uses its battery power in making the transfer (or you need to plug it into AC power).

This multicard reader can handle both Compact Flash (CF) and the SD cards that are used in the XSi. More importantly, it can also handle SDHC cards.

The Card Reader

A card reader can be purchased at most electronics stores. There are several different types, including single-card reader that read only one particular type of memory card, or multi-card readers that are able to utilize several different kinds of cards. (The latter are important with the Rebel XSi only if you have several cameras using different memory card types.)

Note: If you are going to use SDHC memory cards, you must use a card reader that supports SDHC. Just because the card fits into an SD slot does not mean it will work. See page 49 to learn more about SDHC.

After your card reader is connected to your computer, remove the memory card from your camera and put it into the appropriate slot in your card reader.

The card usually shows up as an additional drive on your computer (on Windows XP or Vista and Mac OS 9 or X operating systems—for other versions you may have to install the drivers that come with the card reader). When the computer recognizes the card, it may also give instructions for downloading. If you are unsure how to open and move the files yourself, follow these instructions; however, it is generally faster to simply select your files and drag them to the drive or folder where you want them. Make sure you "eject" the card before removing it from the reader. On Windows you can right click on the drive and select Eject; on a Mac, you can just drag the drive to the trash.

Although card readers can also be used with laptops, a PC card adapter may be more convenient when you're on the move as long as your laptop has a PC card slot. All you need is an adapter for your particular type of memory card. Insert the memory card into the PC adapter, and then insert the PC adapter into your laptop's PC card slot. The computer recognizes this as a new drive. Drag and drop your images from the card to the hard drive. The latest PC card adapters tend to be faster but are also more expensive.

Organizing Files in the Computer

How do you edit and file your digital photos so that they are accessible and easy to use? To start, be sure to edit your photos by removing extraneous shots. Unwanted photos stored on your computer waste space on your hard drive, so save only the ones you intend to keep. Take a moment and review your pictures while the card is still in the camera. Erase the ones you know are unusable, and download the rest. You can also delete photos once they are downloaded to the computer by using an image browser program (described below).

There are myriad ways to organize and process your digital images and none is necessarily more correct than another. It may help to create folders specific to groups of images (i.e., Outdoors, Sports, State Fair, Furniture Displays,

Trying to capture lightning will quickly fill your memory card. Consider erasing the bad images before you download all the "misses" to your computer.

etc.). You can organize your photo folders alphabetically or by date inside a "parent" folder. This digital photography "workflow" is a controversial subject for many photographers. My philosophy is to do what works for your personality. But here's how I deal with digital camera files, which you can note if you want guidance with how to start your own personal workflow.

First, I set up a folder-based filing system on my computer. I have a folder on my hard drive called "Digital Images." Inside that folder are subfolders labeled by year, and within those folders are subfolders for the individual shoots (you could use locations, months, whatever works for you). This is really no different than setting up an office filing cabinet with hanging folders or envelopes to hold photos. Consider the Digital Images folder to be the file cabinet, and the individual folders inside to be the equivalent of the file cabinet's hanging folders.

I use a card reader to download images from my memory card to my computer. Using the computer's file system, I open the memory card as a window or open folder (this is the same basic view on both Windows and Mac computers) showing the images in the appropriate folder. I then open another window or folder that displays my computer's hard drive, and I create a new subfolder within my Digital Images folder's annual subfolder, labeled to signify the photographs on the memory card, such as Place, Topic, Date.

Next, I select all the images in the memory card folder and drag them to my new folder. This copies all the images onto the hard drive and into my "filing cabinet". It is actually better than using a physical filing cabinet. For example, I can use browser software to rename all the photos in the new folder with information about each photo (such as the title _CologneOct08_).

I also set up a group of folders in a separate filing cabinet (a new folder at the level of Digital Images) for edited photos. In this second filing cabinet, I include subfolders specific to types of photography, such as landscapes, close-ups, people, etc. Inside these subfolders, I can break down categories even further when that helps to organize my photos. I include copies of original images that I have examined and decided are definite "keepers," both unprocessed (direct from the camera) and processed images (keeping such files separate). Make sure these are copies (rather than simply moving the files here), as it is important to keep all "original" photo files in the original folder that they went to when first downloaded.

This is a system that works for me and it is one I use for my photography for books, magazines, and other needs. You might use a different system. For instance, you might create your keepers folder at the same level as the folder containing the original images. So you might have two folders in your 2008 folder, one called Malaysia and the other called Malaysia_Edited.

Once you have downloaded your images onto the computer, it's good practice to burn them to a quality CD or DVD as soon as possible. Optical discs take the place of negatives in the digital world. Storing your images only on your hard drive makes you vulnerable. If your copies of an important photo project are stored exclusively on your computer, something could happen to them. Set up a disc binder for your digital "negatives". You may want to keep your original and edited images on separate discs (or separate folders on the same disc).

Image Browser Programs

Browser programs sound like simple applications for viewing your images (in the way that web browsers "view" the internet), but in fact they are a powerful way to edit and organize your images. While many applications that allow you to adjust your images come with browser modules built into the application, they still don't do as well as software specifically made for this purpose. There are currently a number of programs that help you view and organize your images.

ACDSee is a superb program with a customizable interface and keyboard tagging of images. It also has some unique characteristics, such as a calendar feature that lets you find photos by date (though the best-featured version is Windows only). Another good program with similar capabilities was iView Media (with equal features on both Windows and Mac versions). It was purchased by Microsoft and the program is now called Microsoft Expression Media. It is offered in Windows and Mac versions.

There are also programs that combine browsing functions with image-processing features. One of the best known is Adobe Photoshop and its browser known as Bridge. Apple's Aperture, only available for Mac, uses a digital "loupe" to magnify images while browsing. (Aperture is more than just a browser in that it also offers RAW conversion and full image processing.)

Bridge is Adobe's image browser program and integrates with their complete line of image-processing applications.

Adobe's Lightroom is also an option (see page 206). Although its official name is Photoshop Lightroom, I like to leave off Photoshop because it can intimidate photographers. Like Aperture, Lightroom has browsing and cataloging capabilities, but is much more than just a browser. It has full image processing tools as well as tools for printing pictures, making slide shows, and building web pages. The concept behind Lightroom (and Aperture) is to build an application that is specifically designed for photographers, rather than a program that has a lot of tools for other uses.

In addition to the above third-party options, your new EOS Rebel XSi comes with two Canon browser programs: ZoomBrowser EX (Windows) and ImageBrowser (Mac). Both programs let you view and organize RAW and JPEG files. They also convert RAW files, though they are pretty basic programs and don't offer some of the features available in

ImageBrowser and ZoomBrowser EX offer a quick way of examining, editing, and sharing your images.

other RAW processing software (described below). Even so, these do a very good job of translating details from the RAW file into TIFF or JPEG form. Once converted, the new TIFF or JPEG files are readable by any image-processing program. TIFF is the preferred file format (use JPEG only if you have file space limitations).

Most browser programs include some database functions (such as keyword searches) and many operate on both Windows and Mac platforms. These programs allow you to quickly look at photos on your computer, edit them, rename them one at a time or all at once, read all major image file formats, move photos from folder to folder, resize photos for e-mailing, create simple slideshows, and more.

An important function of browser programs is their ability to print customized index prints. You can then give a title to each of the index prints and list additional information about the photographer, as well as the photo's file location.

The index print is a hard copy that allows easy reference (and visual searches). If you include an index print with every CD you burn, you can quickly see what is on the CD and find the file you need. A combination of uniquely labeled file folders on your hard drive, a browser program, and index prints help you maintain a fast and easy way to find and sort images.

Image Processing

One nice thing about JPEG is that it is one of the most universally recognized formats. Any program on any computer that recognizes image files recognizes JPEG, and you can process the Rebel XSi's JPEG files in nearly any image-processing program. That being said, it is important to understand that the original JPEG file is more like a negative than a slide. Sure, you can use it directly, just like you could have the local mini-lab make prints from negatives. But JPEG files can be processed to get more out of them.

Note: While RAW files offer more capacity for change, you can still optimize a JPEG file for use. I shoot a lot of JPEGs when it fits my workflow, and no one complains about the quality of my images.

RAW, as mentioned earlier, requires special software programs—not standard image-processing programs—to open and convert the RAW files. RAW is an important format because it increases the options for adjustment of your images (see page 107). In addition, Canon's RAW file, CR2, offers increased flexibility and control over the image. When shooting RAW, you have to work on every image, which changes your workflow. This is why photographers who need to work with RAW sometimes use the Rebel XSi's ability to record RAW and JPEG at the same time.

There are a number of very good RAW conversion programs available these days, including Capture One, Bibble, Silkypix, and LightZone, to name a few. However, one dis-

RAW processing gives you the chance to recover detail from difficult exposures. But don't let the use of RAW become a crutch that prevents you from getting good exposures in the first place.

advantage of most of these conversion programs is that they are not integrated into any image-processing software: You have to open and work on your photo, then save it and reopen it in an editing program such as Photoshop, Adobe Photoshop Elements, Paintshop Pro, Picasa, etc. Adobe met this challenge by including RAW conversion capabilities in its versions of Photoshop CS, in Photoshop Elements, and in Lightroom.

Photoshop has long been the go-to application for processing and enhancing images. Still, with its powerful set of tools, plug-ins, menus, and features, Photoshop's complexity can be intimidating for many photographers. Adobe's recent application, Photoshop Lightroom, is designed from the ground up for photographers. Whereas Photoshop has become crowded with features that are useful to graphic artists and aid in non-photography image creation, Light-

room is strictly focused on a digital photography workflow. Make no mistake, Lightroom is not "Photoshop-Light." It is a full image editing, processing, and outputting application.

When you process a RAW file in Photoshop, a separate application called Adobe Camera RAW opens up. You adjust your image, then process it, and it is automatically sent back to Photoshop. If you need to re-adjust the processing, you must bring it back to Adobe Camera RAW. When you use Lightroom however, RAW processing is built in, so you can instantly go back and make changes without leaving the Lightroom application. As mentioned above, RAW process-ing is non-destructive. Lightroom edits JPEG images non-destructively, too. So if you shoot JPEG all of the time you don't lose the advantage of non-destructive image editing.

Note: Since the XSi was introduced after Photoshop CS3 and Lightroom were developed, you may need to download soft-ware updates from Adobe's website so these applications can work on XSi RAW files.

Digital Photo Professional Software

This is Canon's advanced proprietary program for processing RAW and JPEG images. Once an optional program and now included with the Rebel XSi, Digital Photo Professional (DPP) was developed to bring Canon RAW file-processing up to speed with the rest of the digital world.

DPP even has some batch processing features. It can allow continuous work on images while other files are ren-dered and saved in the background. Once images have been adjusted in DPP, they can be transferred immediately to Pho-toshop. There is no question that DPP really helps streamline the workflow of any photographer who wants to work with CR2 files.

A key feature is the program's ability to save adjustments to a file that can then be reloaded and applied again to the original or to other RAW files. The program includes a whole range of valuable controls, such as tone curves, exposure

Digital Photo Professional comes with the XSi and provides a host of tools for processing your RAW images.

compensation, white balance, dynamic range, brightness, contrast, color saturation, and more. There is also a comparison mode that allows original and edited images to be compared side by side or in a split image.

DPP has an improved processing engine and can be used to process JPEG as well as CR2 files. The advantage to processing JPEG files is that DPP is quicker and easier to use than Photoshop CS versions, yet it is still quite powerful. There is also a small processing advantage over third-party programs when using this Canon software, which, after all, was created specifically for Canon's CR2 format. I believe if you are going to shoot RAW, this is a must-use program. It is fast, full-featured and gives excellent results, and also is the only RAW processing program that gives you the ability to use Dust Delete Data that is embedded in the RAW file (see page 54).

EOS Utility

This Canon application, also provided with your Rebel XSi, serves as a gateway for several XSi operations. It is used to download images (all images or just those selected) when the camera is connected via USB to the computer. It can also be used to shoot remotely, to create or update My Menu, and to shoot photos at timed intervals.

The EOS Utility is used for remote or "tethered" shooting. When you select the EOS Utility's remote shooting feature, a remote control panel displays on the computer. This panel enables you to fire the shutter, choose exposure mode, and adjust shutter speed, aperture, ISO, white balance, metering mode and file recording type.

The EOS Utility Remote Control Panel.

The control panel has its own set of menus that is a stripped down version of the XSi's menu system (Shooting, Set-up, and My Menu). This Shooting menu offers access to white balance shift and Picture Styles. The Picture Style option goes one step further in that it can upload new styles from your computer (see page 211). The Set-up menu allows you to set the camera owner's name, set the date and time, enable Live View shooting, and upload camera firmware.

209

You can also quickly and easily manage your options for My Menu ⚙ when tethered. Even if you never shoot using the EOS Utility, consider hooking up the camera to set up ⚙ . Instead of scrolling through seemingly endless options on the small XSi LCD monitor, use the remote camera control to point and click your way through choices.

While tethered, you can turn on the Live View shooting for a powerful studio-style, image preview shooting setup. An instant histogram and the ability to check focus on a larger computer display help during tethered Live View. You have the choice of capturing the images to the computer, or to the computer and the memory card in the XSi. As you capture each picture, it can open automatically in Digital Photo Professional or in the image-processing program of your choice.

EOS Utility also offers the option of timed shooting. The computer acts as an intervalometer, taking a picture every few seconds (from 5 seconds to 99 hours and 59 seconds). You can also use **BULB** exposure mode from 5 seconds to 99 hours and 59 seconds.

Note: Live View, timed, or Bulb shooting will, in most cases, require the computer and camera to use AC power.

Picture Style Editor
Introduced with the Canon EOS 1D Mark III, the Picture Style Editor (included with your Rebel XSi) lets you create your own styles. When you import a RAW image, you can adjust its overall tone curve much as you would in an image-processing program. You can also adjust the normal picture style parameters of Sharpness, Contrast, Saturation and Color tone.

But the Picture Style Editor's most powerful feature is the ability to change individual colors in the image. Use an eyedropper tool to pick a color and then adjust the hue, saturation and luminance values of the color. You can pick multiple colors and also choose how wide or narrow a range of colors (around the selected color) is adjusted. These custom

A custom picture style can be used to personalize your "look" with the XSi. You can even make this scene look green or brown, depending on the feeling you want to portray.

picture styles can then be uploaded to the XSi using the EOS Utility. You can also download new Picture Styles that have been created by Canon engineers at:

www.usa.canon.com/content/picturestyle/file/index.html

Storing Your Images

Your digital images can be lost or destroyed if you do not take proper care of them. Many photographers back up their image files with a second drive, either added to the inside of the computer or as an external USB or FireWire drive. For more permanent backup, burn your images to CD or DVD. While Blu-ray offers more storage capacity than DVD, I think it is too early in the development cycle of this technology to trust it for reliable storage—just ask anyone who remembers the early days of burning your own CDs.

Don't lose your images through human error or digital glitch. Make sure you have a reliable archive system on which to store the photos you've worked so hard to capture.

Hard drives and memory cards do a great job of recording image files for processing, transmitting, and sharing, but they are not good for long-term storage. This type of media has been known to lose data within ten years. And since drives and cards are getting progressively larger, the chance that a failure will wipe out thousands of images rather than "just one roll" is always increasing.

Computer viruses can also wipe out image files from a hard drive. Even the best drives can crash, rendering them unusable. Plus, we are all capable of accidentally erasing or saving over an important photo.

The answer to these storage problems is optical media. A CD-writer (or burner) is a necessity for the digital photographer. DVD-writers work extremely well, too, and DVDs can handle about seven times the data that can be saved on a CD. Either option allows you to back up photo files and store images safely.

There are two types of disc media that can be used for recording data: R designated (i.e. CD-R or DVD-R) recordable discs; and RW designated (i.e. CD-RW or DVD-RW) rewritable discs. CD-R discs can only be recorded once—they cannot be erased and no new images can be added to them. CD-RWs, on the other hand, can be recorded on, erased, then reused later . . . and you can add more data to them as well. However, if you want long-term storage of your images, use CD-R or DVD-R disks rather than CD-RWs or DVD-RWs. (The latter is best used for temporary storage, such as transporting images to a new location.) The storage medium used for -R discs is more stable than that of -RWs (which makes sense since the CD-RWs are designed to be erasable).

Nowadays there are two more DVD formats: DVD+R and DVD+RW. The same warning goes for +RW as for -RW. Many people swear by DVD+R, but my experience is that there are more -R drives out there than +R. If you want to send a disc to someone, they are more likely to have a -R drive. Most new drives are able to read both formats.

Buy quality media. Inexpensive discs may not preserve your photo files as long as you would like. Read the box. Look for information about the life of the disk. Most long-lived discs are labeled as such and cost a little more. And once you have written to the disc, store and handle it properly.

Direct Printing

With certain compatible Canon printers, you can control the photo printing directly from the Rebel XSi. Simply connect the camera to the printer using the dedicated USB cord that comes with the printer. Compatible Canon printers have many direct printing options including:
• Contact-sheet style 35-image index prints
• Printed shooting information
• Face brightening
• Red-eye reduction

- Print sizes: 4 x 8, 10 x 12, 8 x 10, 14 x 17 inches
- Support for other paper types
- Print effects: Natural, B/W, Cool Tone, Warm Tone

In addition, the camera is PictBridge compatible, meaning that it can be directly connected to PictBridge printers from several manufacturers. Nearly all new photo printers are PictBridge compatible. When you use these printers, use the USB cord that comes with the camera.

Note: RAW files cannot be used for the direct printing options mentioned in this section.

To start the process, first make sure that both the camera and the printer are turned off, then connect the camera to the printer with the camera's USB cord. (The connections are straightforward since the plugs only work one way.) Turn on the printer first, then the camera—this lets the camera recognize the printer so it is prepared to control it. (Some printers may turn on automatically when the power cable is connected.) Depending on the printer, the camera's direct printing features vary.

Press ▶ and use ◀▶ to select an image on the LCD monitor that you want to print. The ⚐ icon displays in the upper left to indicate the printer is connected. Press ⚪ and the <Print Setting> screen appears, displaying printing choices such as whether to imprint the date, what effects to include (if any), the number of copies, trimming area, and paper settings (size, type, borders or borderless). Depending on the printer, press DISP. to adjust the brightness, change levels while viewing a histogram, lighten faces in backlit shots, and apply red-eye correction.

The XSi provides an abundance of options to optimize prints made ▷ *directly from the camera, including the ability to enhance the picture's brightness, contrast, saturation, and tone, as well as the flexibility to crop (trim) the image.*

Trimming is a great choice because it allows you to crop your photo right in the LCD monitor before printing, so you can tighten up the composition if needed. This is accomplished by using the ⊕ and ▣·⊖ buttons to adjust the size of the crop, and then ✧ to adjust the position of the crop. You can also use 🗝 to tilt your image 10 degrees either way in order to straighten a crooked horizon. Press ⑤ to accept the crop setting.

Continue to use ✧ to select other desired settings. These choices may change depending on the printer; refer to the printer's manual if necessary.

Once you have selected the options you want, select <Print> to start printing. The Print/Share button 🖥〜 flashes, alerting you not to disconnect the USB cable. If you wish to use the same settings for additional prints, use ◀▶ to move to the next picture and then simply press 🖥〜 to print the next image.

Note: The amount of control you have over the image when printing directly from the camera is limited solely by the printer. You will often have little or no control over color and brightness. If you really need image control, print from the computer.

If you shoot a lot of images for direct printing, do some test shots and set up the Rebel XSi's Picture Styles to optimize the prints before shooting the final pictures. You may even want to create a custom setting that increases sharpness and saturation just for this purpose.

Digital Print Order Format (DPOF)

Another Rebel XSi printing feature is DPOF (Digital Print Order Format). This allows you to decide which images to print before you actually do any printing. Then, if you have a printer that recognizes DPOF, it automatically prints the chosen images. It is also a way to select images on a mem-

DPOF is a menu item that lets you choose certain images stored on your memory card for printing. This is handy if you want to drop your memory card at a photofinisher and don't want to pay to have all the files printed.

ory card for printing at a photo lab. When you drop off your SD card with images selected using DPOF—assuming the lab's equipment recognizes DPOF (ask before you leave your card)—the lab knows which prints you want.

DPOF is accessible through the ▣⁺ Menu under <Print Order>. You can set the options you want, choosing all or any combination of individual images. Select <Set Up> to choose Print type (<Standard>, <Index>, or <Both>), Date (<On> or <Off>), and File No. (<On> or <Off>). After setting up your choices, press **MENU** to return to <Print Order>. From there, choose either <Sel. Image> or <All image>. <Sel. Image> allows you to use ▲▼ to select the individual images you want to print, along with their quantity, while <All image> selects all the images on the card for printing. RAW files cannot be selected for DPOF printing.

Glossary

AE
See automatic exposure.

AF
See autofocus.

angle of view
The area seen by a lens, usually measured in degrees across the diagonal of the film frame.

aperture
The opening in the lens that allows light to enter the camera. Aperture is usually described as an f/number. The higher the f/number, the smaller the aperture; and the lower the f/number, the larger the aperture.

Aperture-Priority mode
A type of automatic exposure in which you manually select the aperture and the camera automatically selects the shutter speed.

autofocus
When the camera automatically adjusts the lens elements to sharply render the subject.

automatic exposure
When the camera measures light and makes the adjustments necessary to create proper image density on sensitized media.

automatic flash
An electronic flash unit that reads light reflected off a subject (from either a preflash or the actual flash exposure), then shuts itself off as soon as ample light has reached the sensitized medium.

Av
Aperture Value.
See Aperture-Priority mode.

backlight
Light that projects toward the camera from behind the subject.

bit depth
The number of bits per pixel that determines the number of colors the image can display. Eight bits per pixel is the minimum requirement for a photo-quality color image.

bounce light
Light that reflects off of another surface before illuminating the subject.

brightness
A subjective measure of illumination.

bulb
A camera setting that allows the shutter to stay open as long as the shutter release is depressed.

card reader
Device that connects to your computer and enables quick and easy download of images from memory card to computer.

close-up
A general term used to describe an image created by closely focusing on a subject. Often involves the use of special lenses or extension tubes.

color cast
A colored hue over the image often caused by improper lighting or incorrect white balance settings. Can be produced intentionally for creative effect.

compression
A method of reducing file size through removal of redundant data, as with the JPEG file format.

contrast
The difference between two or more tones in terms of luminance, density, or darkness.

cropping
The process of extracting a portion of the image area.

dedicated flash
An electronic flash unit that talks with the camera, communicating things such as flash illumination, lens focal length, subject distance, and sometimes flash status.

electronic flash
A device with a glass or plastic tube filled with gas that, when electrified, creates an intense flash of light.

EXIF
Exchangeable Image File Format. This format is used for storing an image file's interchange information.

exposure
When light enters a camera and reacts with the sensitized medium. It also refers to the amount of light that strikes the sensitized medium.

extension tube
A hollow metal ring that can be fitted between the camera and lens (it usually includes mechanical and electronic connectors so the camera and lens still work normally). It increases the distance between the optical center of the lens and the sensor and decreases the minimum focus distance of the lens.

file format
The form in which digital images are stored and recorded, e.g., JPEG, RAW, TIFF, etc.

filter
A piece of plastic or glass used to control how certain wavelengths of light are recorded. A filter absorbs selected wavelengths, preventing them from reaching the sensitized medium. Also, software available in image-processing computer programs that produces special filter effects.

f/stop
The size of the aperture or diaphragm opening of a lens, also referred to as f/number or stop. Each stop up (lower f/number) doubles the amount of light reaching the sensitized medium. Each stop down (higher f/number) halves the amount of light reaching the sensitized medium.

GN
See guide number.

guide number
A number used to quantify the output of a flash unit. It is derived by using this formula: GN = aperture x distance. Guide numbers are expressed for a given ISO film speed in either feet or meters.

High-speed sync (Flash mode)
This allows flash units to be synchronized at shutter speeds higher than the standard sync speed. In this flash mode, the level of flash output is reduced and, consequently, the shooting range is reduced.

histogram
A graphic representation of image tones.

hot shoe
An electronically connected flash mount on the camera body. It enables direct connection between the camera and an external flash, and synchronizes the shutter release with the firing of the flash.

image-processing program
Software that allows for image adjustment, alteration and enhancement.

IS
Image Stabilization. This is a technology that reduces camera shake and vibration. It is used in lenses, binoculars, camcorders, etc.

ISO
When an ISO number is applied to film, it indicates the relative light sensitivity of the recording medium. Digital sensors use film

ISO equivalents, which are based on enhancing the data stream or boosting the signal.

JPEG
Joint Photographic Experts Group. This is a lossy compression file format that works with any computer and photo software.

lens
The optics in front of a camera that have been designed for photo use with multiple glass elements to control angle of view (focal length) and sharp images on the sensor or film.

lens hood
Also called a lens shade. This is a short tube that can be attached to the front of a lens to reduce flare. It keeps undesirable light from reaching the front of the lens.

light meter
Also called an exposure meter, it is a device that measures light levels and calculates the correct aperture and shutter speed.

M
See Manual exposure mode.

macro lens
A lens designed to be at top sharpness over a flat field when focused at close distances and reproduction ratios up to 1:1.

Manual exposure mode
A camera operating mode that requires the user to determine and set both the aperture and shutter speed. This is the opposite of automatic exposure.

megapixel
A million pixels.

memory card
A solid state removable storage medium used in digital devices. It can store still images, moving images, or sound, as well as related file data.

menu
A listing of features, functions, or options displayed on a screen that can be selected and activated by the user.

midtone
The tone that appears as medium brightness, or medium gray tone, in a photographic print.

normal lens
See standard lens.

overexposed
When too much light is recorded with the image, causing the photo to be too light or washed out in tone.

pixel
The base component of a digital image. Every individual pixel can have a distinct color and tone.

Program mode
In Program exposure mode, the camera selects a combination of shutter speed and aperture automatically.

RAW
An image file format that has little or no internal processing applied by the camera. It contains 14-bit color information, a wider range of data than 8-bit formats such as JPEG.

RAW+JPEG
A file recording choice that records two files per capture: one RAW file and one JPEG file.

rear curtain sync
A feature that causes the flash unit to fire just prior to the shutter closing. It is used for creative effect when mixing flash and ambient light.

resolution
The amount of data available for an image as applied to image size. It is often expressed in pixels or megapixels.

shutter
The apparatus that controls the amount of time during which light is allowed to reach the film or sensor.

Shutter-Priority mode
An automatic exposure mode in which you manually select the shutter speed and the camera automatically selects the aperture.

Single-lens reflex
See SLR.

slow sync
A flash mode in which a slow shutter speed is used with the flash in order to allow low-level ambient light to be recorded.

SLR
Single-lens reflex. A camera with a mirror that reflects the image from the lens onto the viewfinder screen. A pentaprism or pentamirror then allows you to see that screen through the eyepiece. When you take the picture, the mirror reflexes out of the way, the focal plane shutter opens, and the image is recorded.

standard lens
Also known as a normal lens, this is a fixed-focal-length lens usually in the range of 45 to 55mm for 35mm format (or the equivalent range for small-format sensors).

synchronize
Causing a flash unit to fire simultaneously with the complete opening of the camera's shutter.

telephoto lens
A lens with a long focal length that enlarges the subject and produces a narrower angle of view than you would see with your eyes.

tripod
A three-legged stand that stabilizes the camera and eliminates camera shake caused by body movement or vibration.

TTL
Through-the-Lens, i.e. TTL metering.

Tv
Time Value.
See Shutter-Priority mode.

viewfinder screen
The ground glass surface on which you view your image.

wide-angle lens
A lens that lets you see a scene with an angle of view wider than the typical standard or normal lens.

zoom lens
A lens that adjusts to cover a wide range of focal lengths.

Index

A-DEP mode *(see Automatic Depth-of-Field mode)*
AEB *(see autoexposure bracketing)*
AE Lock **71**, 125, **143–144**
AF-assist beam 70, 111
AF modes **115–116**
AF point 38, 39, 44, 113, **117–118**, 149, 150
AI Focus AF 113, **116**
AI Servo AF 57, 71, 113, 114, **116**
ambient light 68, 134, 136, 157, 158, 160, 161, 162
Aperture-Priority AE mode (Av) 124, **140-141**, 161
Auto power off **37**, 56, 62
autoexposure bracketing 61, 68, **146-148**
Automatic Depth-of-Field **141**, 162

Basic Zone shooting modes 33, 35, 56, 64, 85, 86, 110, 115, 122, **131–134**, 157, 160
batteries **43–44**, 75, 150
browser programs **202–205**
built-in flash 114, **156–158**, 160, 165
Bulb Exposure 48, 136, **143**, 210

card reader 49, 197, **198**
Center-weighted Average metering **127**
cleaning camera **52-54**
cleaning sensor 44, **55** *(see also self-cleaning sensor)*
close-up lenses **188-191**
Close-up mode **133**
color cast 95, 172
color space 61, 93
color temperature 22, 93, 95
compression 21, 22, 104, 106, 108, 111
Continuous shooting drive 46, 57, 85, 120, 133
CR2 *(see also RAW)* 22, 103, 104, 107, 111, 205, 207, 208
Creative Zone shooting mode 33, 56, 95, 115, 122, **134–143**, 148, 157, 158, 160
cropping factor *(see magnification factor)*
Custom Functions 64, 65, **67–72**, 110, 167, 169

Dust Delete Data 28, 54, 61, 108, 208
depth of field 132, 133, 137, 138, 140-142, 151, 161, 190, 192
depth-of-field preview 39, 140, 151
DIGIC III 83-84, 94, 105, 110
diopter 40
DPOF 62, **216–217**
drive modes 119–121

erasing images 27, 51, 62, 75, **78–80**, 199
E-TTL 156, 158, 160, 166, 170, 171, **173**
Evaluative metering **124–126**, 132, 159
exposure compensation 68, 125, **145–146**, 151

Faithful Picture Style 87
FE lock **162**
file formats **21–22**, **104–111**, 204
filters 23, 90, 101, **184–188**
flash **153–173**
flash exposure compensation 56, 71, **164**
flash metering 158–159
Flash off mode **134**
flash synchronization **154–155**, 160, 170, 131
focusing 113–118
formatting memory card **51–52**
Full Auto shooting mode **132**

guide number (GN) **156**, 167

Highlight alert 76, **128–129**
histogram **17–18**, 62, 76, **128–131**, 146, 151, 210, 214

image processing (computer) 87, 93, 96, 104, 131, 147, **202–211**
image protection 51, 61, **79–80**

image recording quality 56, 71, 76, **108–111**
image review **73–75**, 138
image size 56, **108–111**
ISO **19–21**, 47, 57, 69, **122–124**, 136, 156

JPEG 21, **22**, 27, 83, 84, **104–106**, 108–111, 120, 132, 203–205, 208

Landscape Picture Style **86**, 132
Landscape shooting mode **85**, 86, 132
LCD monitor 16, 35, **40–43**, 59–63, 72, **73–78**
lenses **175–184**, **188–190**
Live View 13, 34, 44, 63, 70, 73, 110, **148–151**, 209, 210

magnification factor 46, 175, 126, 180
magnify image 42, **77–78**, 150
Manual Exposure shooting mode (M) 69, 124, 131, **142**, 162
manual focusing 39, 118, 125, 142, 149, 191
memory card **48–49** (see also SD or SDHC)
menus **34–35**, **59–73**
metering 16, **124–127**, 142, 145, 151 (see also flash metering)
Mirror lockup
Monochrome Picture Style **88**, 90
My Menu 35, 59, **64–66**, 209, 210

Neutral Picture Style **87**
Night Portrait shooting mode **133**
noise reduction 21, 68, 69, 143

One-shot AF 115, **116**

Partial metering **126**, 142
Picture Styles 28, 56, 61, **85–92**, 108, 132, 133, 134, 150, 209, 210
playback (see image review)
Playback menu 35, 59, 61–62
Portrait Picture Style **86**, 132
Portrait shooting mode **132**
printing 35, 49 110, **213–217**
Program AE shooting mode **134–135**, 160
program shift 135
protect images (see image protection)

Quality (see image recording quality)

RAW **21–22**, 24, 27, 28, 60, 71, 83, 84, 93, 103, **104–111**, 131, 203, 205–208, 214, 217
RAW+JPEG 84, 88, **110**
red-eye reduction **165–166**
remote control 48, 57, **120**, 143, 195, 209
reset 37, 89, 92
resolution **23–24**, 66, 108

SD 48–49, 198
SDHC 49, 198
self-cleaning sensor 53–54
self-timer 48, 57, **120**
sensor 13, 16, 28, **45–47**, 54–55
Set-up Menu 1 35, 59 **62**
Set-up Menu 2 35, 59, **63**
Set-up Menu 3 35, 59, **64**
Shooting Menu 1 35, 59, **60**
Shooting Menu 2 35, 59, **61**
Shutter-Priority AE shooting mode (Tv) 124, **136–139**, 160
Single shooting drive 47, 56, **119**, 132
Speedlite flash units (see flash)
Sports shooting mode **133**
Spot metering 124, **127**
Standard Picture Style **85**, 132, 133

tripod 47, 120, 127, 134, 13, 147, 161, 175, 191, **194–195**
TV playback **80**

User-defined Picture Styles **91**

viewfinder **38–40**, 43, 47, 56, 69, 70, 116, 117, 127, 140, 141, 145, 148, 151

white balance **22–23**, 57, 61, 83, **93–103,** 108, 110
white balance auto bracketing **102–103**

224